IMAGES
of America

HISTORIC DANCE HALLS OF EAST CENTRAL TEXAS

IMAGES
of America

HISTORIC DANCE
HALLS OF EAST
CENTRAL TEXAS

Stephen Dean

ARCADIA
PUBLISHING

Published by Arcadia Publishing
Charleston, South Carolina

Printed in the United States of America

Library of Congress Control Number: 2013954266

For all general information, please contact Arcadia Publishing:
Telephone 843-853-2070
Fax 843-853-0044
E-mail sales@arcadiapublishing.com
For customer service and orders:
Toll-Free 1-888-313-2665

Visit us on the Internet at www.arcadiapublishing.com

To Elaine Dean.
"My mother had a great deal of trouble with me,
but I think she enjoyed it."
—Mark Twain

CONTENTS

ACKNOWLEDGMENTS

Thanks go to Judy Pate and the E.A. Arnim Museum in Flatonia, the Fayette Public Library in LaGrange, Roger Kolar of Negrete & Kolar Architects, and the SPJST Archives in Temple.

I want to thank the following for their previous research into the Texas dance halls: Kevin Alter and Krista Whitson, *Dance Halls of Central Texas*; Geronimo Trevino, *Dance Halls and Last Calls: A History of Texas Country Music*; Gail Folkins, *Texas Dance Halls: A Two-Step Circuit*; and the Austin County Historical Commission, *Dance Halls of Austin County*.

Thanks to Deb Fleming, Lisa Dean, Paris Simpson, Philip Barnard, and Andrea Bohon for their assistance in driving, navigating, and helping me enjoy the ride. Thanks to Sherry Caine for some last-minute assistance.

Finally, I want to thank the board members of the Texas Dance Hall Preservation (www.texasdancehall.org), who have encouraged me and helped me shed light on these iconic Texas halls: Patrick Sparks, Anna Mod, and Sharon Kleinecke.

Unless otherwise noted, images are from the author's collection.

INTRODUCTION

At the end of the Mexican War of Independence, the population of Texas was a mere 2,500. Then, leading up to 1834, massive immigration swelled the number to an estimated 20,000. In 1821, there were a mere three towns in Texas, but that number soon increased to 21 by 1835, due mostly to Anglo immigrants after Mexican independence. Immigration from the United States to Texas produced new political directions for the province from 1821 to 1836. By the end of the Mexican period, therefore, great changes were apparent in Texas. The Anglos established a different language, implemented a republican form of government, and introduced new Christian communions. In addition, they created a social order wherein minorities, among them some Mexican Texans who assisted in the struggles of the 1830s, were subordinated, and, overall, gave the region unique Anglo American characteristics.

Events in Europe spawned new immigration, and as the 1840s and 1850s transpired, the new republic started taking on a new look, due to incoming Germans, Czechs, and the Polish. These émigrés from Central Europe brought with them traditional artisanal building crafts and, just as important, a powerful desire to reproduce and maintain their cultural heritage, including language, music, dance, and vernacular architectural styles. The new communities often erected community halls as their first buildings, as they served multiple purposes. The halls were instrumental in keeping traditions alive and nurtured the music and dance coming from Europe.

The European immigration routes during those times reached America at either Indianola or Galveston and then proceeded westward to new settlements, from the coast to as far as the Hill Country. This volume will concentrate on the area that is now referred to as East Central Texas, where many of the new immigrants settled. The western expansion highlighted in this book ends near Austin or, better, the Balcones Escarpment, where the terrain begins to change significantly. The southern border is where the rainfall drops considerably. This land was used mostly for the huge expansion of cattle ranching, initially introduced by the Spanish during their rule. The northern boundary is the territory first taken by Spanish land grants deeded to the first US expansion and Stephen F. Austin's colony in 1821.

The halls differ significantly from one another for many reasons, including the town's financial standing, the size of the community, and often the skills of that area's craftsmen, builders, or designers. Some halls were basic, and some were products of master builders. The halls were erected with building techniques and skills learned in the old country but adapted for Texas's sometimes harsh environment. They did have one thing in common: the hardwood floor that was made for celebration and dance. Unknown at the time, this dance culture would continue through the generations and have a profound effect on Texas culture and, in particular, on the state's world-famous music. Had it not been for these venerable halls, the region's endearing music might have been lost. From the early days of brass-band music, through styles that were later birthed or nurtured such as polka, Conjunto, Western swing, country (or hillbilly), and later, blues, jazz, zydeco, and even rock 'n' roll, the halls are iconic testaments to Texas's rich melting pot of culture.

It is my wish with these books to help promote and preserve these institutions for future generations. We have lost many of these dance halls, but many remain, and I hope you can visit and enjoy the magic that is Texas dance halls. For further information and ways to help, please contact the author or visit the nonprofit Texas Dance Hall Preservation at www.texasdancehall.org.

One

AUSTIN COUNTY

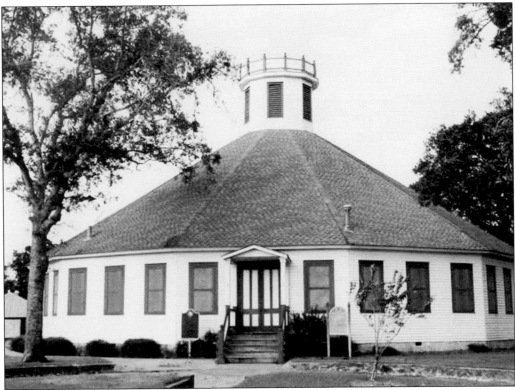

BELLVILLE TURNVEREIN HALL. In 1895, the Bellville Turnverein Gut Heil, a German athletic club, purchased the Bellville Social Club's property and hired local contractor Joachim Hintz to build this pavilion. Completed in 1897, it was the first of several polygonal social halls built in Austin County by the now-renowned Hintz. The city of Bellville purchased the property and pavilion in 1937, and it continues to serve as a focal point for many community gatherings. It is located at FM 159 and FM 329 at City Park in Bellville.

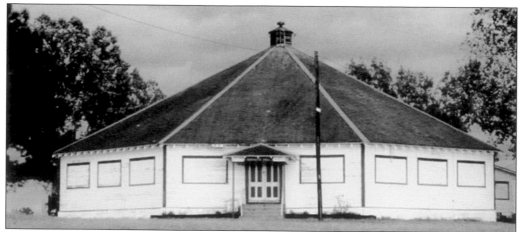

NEW COSHATTE HALL. The present Coshatte Hall, built in 1928, was used primarily for dancing, hence the newly added elevated area for orchestras. In 1950, the name was changed from Coshatte Turnverein to the Coshatte Agricultural Society Hall. The six-sided, round structure is located off Highway 529 east of Bellville, on the corner of Coshatte and Waak Roads. The turnverein movement was brought to the United States by Forty-Eighters, political refugees from Germany who were ardent practitioners of the gymnastic system begun in 1811 by Friedrich Ludwig Jahn.

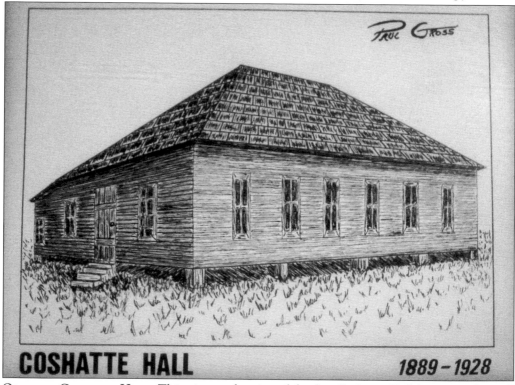

COSHATTE HALL 1889 – 1928

ORIGINAL COSHATTE HALL. This vintage drawing of the first Coshatte Hall hangs on the wall in the new hall. This structure was built on land donated by Carl Timme for a school and for recreation purposes. In 1883, it was a simple dance platform supervised by the Coshatte Turnverein. Then, in 1889, the rectangular hall shown here took its place. The Sons of Hermann also used this building. It was rebuilt into the present six-sided hall in 1928. (Courtesy of Coshatte Hall.)

BLEIBLERVILLE HALL. Bleiblerville SPJST (Slovanska Podporujici Jednota Statu Texas) is a Czech culture and insurance fraternal club. Lodge No. 33 was founded in 1900, and the club built a lodge hall on Highway 2502. The present hall was completed in 1915 after Paul Albert, of Albert's Store, sold an acre to the lodge. Merkel and Matach were the builders. In 1955, the lodge hall underwent remodeling, including the addition of a kitchen and central air and heat. In 1993, Nelsonville Lodge merged with Bleiblerville Lodge. The club still holds an annual fish fry every spring and fall, as well as community dances, family reunions, and church and school functions.

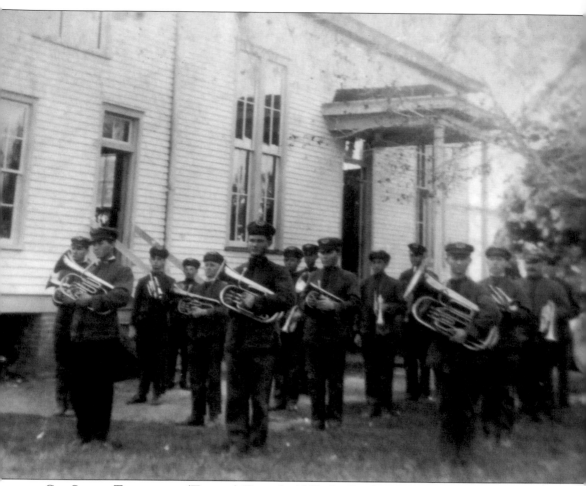

Cat Spring Turnverein (Turner) Hall. In 1869, the Cat Spring Turnverein was established. It soon built a hall in the old Cat Spring settlement. The hall burned down in 1895. Since 1854, there have been 28 turnvereins in 21 Texas communities. As soon as possible after formation, all of these clubs acquired halls spacious enough to accommodate gymnastics. The hall shown here was the second hall built, and it was the first built by Joaquim Hintz. (Courtesy of Larry Uhlig.)

CAT SPRING TURNER HALL ADVERTISEMENT.
This is a c. 1930s advertisement for a free
dance at the Turner Hall in Cat Spring.
The Happy Pals Band was a local outfit that
played mostly for fun around Cat Spring. The
bands at the time depended on the area's
newspapers for engagement announcements.

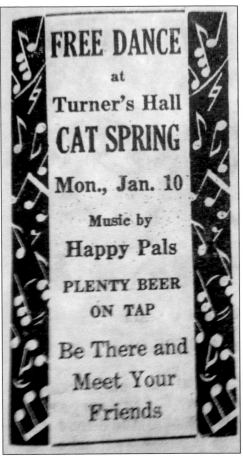

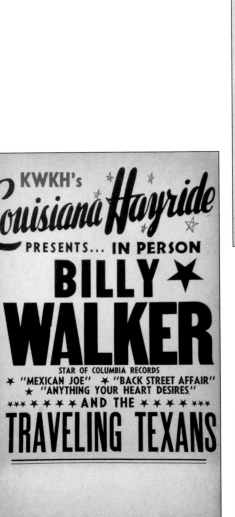

BILLY WALKER POSTER. This 1950s dance
hall poster promotes Billy Walker, a Texas-
born country music performer. He spent
a great deal of time playing in the Texas
dance halls of the 1950s and later, even
after he joined the Louisiana Hayride
and moved to Nashville. The Louisiana
Hayride, second in popularity only to the
Grand Ole Opry in Nashville, was the first
stop when touring the numerous locations
of the fruitful Texas dance hall circuit.

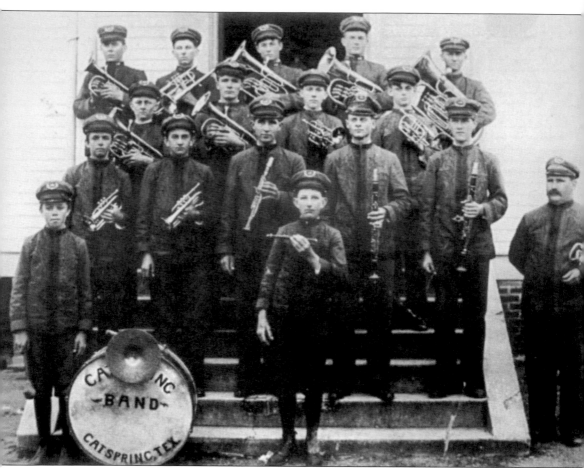

CAT SPRING BAND. This band played for German gatherings such as Spring Fest, the Fourth of July, Harvest Fest, masked balls, Maifest, New Year's Eve, and Christmas-tree dances. Germans introduced the Christmas-tree tradition to Texas and the United States. Many of the early settlers to Cat Spring were more intellectuals than farmers, so it was decided to form an Agricultural Club for education purposes. Organized in 1856, the Landwirth Schaftlide Verein (agricultural club) was chartered in 1888. Many of its early dances were held on a platform that was taken apart after the dance. In later years, the dances took place at the Turner Hall. (Courtesy of Fayette County Library.)

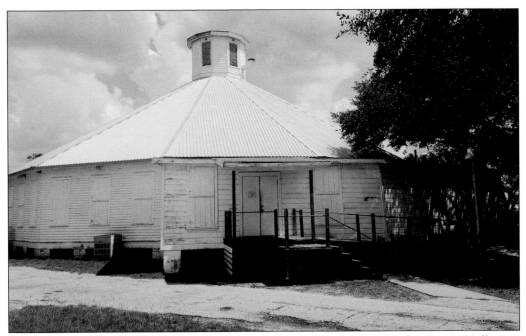

CAT SPRING AGRICULTURAL HALL. Not much has been changed to the Cat Spring Hall, seen here as it looks today. The structure is still a vibrant and often-used hall, and it is the pride of a burgeoning tourist destination. Among the events held here are semi-annual antiques fairs, the Spring Festival, the Fall Festival, and dances with polka and country music.

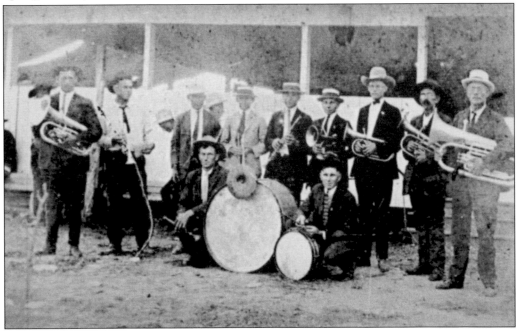

FRYDEK PLEASURE HALL AND JOE SAHA BAND. This hall, built by Joe Pavlicek in 1920, was located at a crossroads in town at FM 1458. In the late 1920s, the hall was purchased by Joe Svinky and became known as Svinky Hall. It lasted until 1940, when it was sold and dismantled for the use of its lumber in other buildings. Here, the Joe Saha Band stands in front of the hall for a portrait.

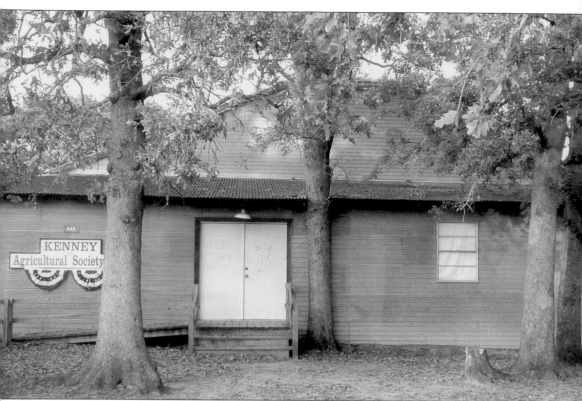

KENNEY AGRICULTURE HALL. Kenney is at the junction of Farm Road 2754 and Highway 36, eight miles north of Bellville in far northern Austin County. Settlement in the vicinity began in the late 1820s, with several waves of German immigration reaching the area between the 1830s and 1900. The Agricultural Society of Kenney was formed in 1902. There was also a Hermann Sons lodge and a Germania Schuetzen Verein (German Shooting Club) in Kenney. All three of these clubs shared the hall. In 1950 the hall was destroyed by a storm, but it was replaced in 1951 with the present hall.

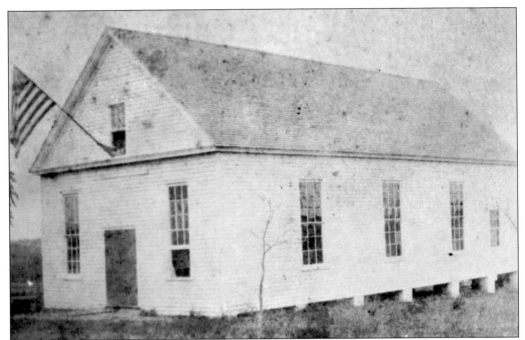

MILLHEIM HARMONIE HALL. The town of Millheim was established eight miles south of Bellville in central Austin County about 1845 when a mill was constructed on Clear Creek, a tributary of Mill Creek. The founders of the community were German immigrants who moved southeast through Mill Creek Valley from settlements in the vicinity of Cat Spring. This is the first Millheim Harmonie Hall, built in 1874.

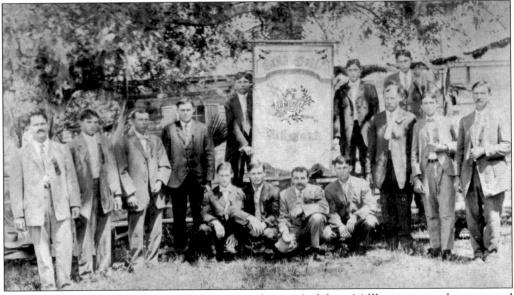

MILLHEIM SINGING CLUB. An early harmonie (singing) club in Millheim is seen here around 1915. German harmonie clubs or associations were formed when the earliest Germans came to Texas. These clubs were organized for the purpose of singing traditional German songs and keeping traditions alive. Many of these clubs built harmonie halls for their own use and for annual competitions, or Saengerfests (German song festivals).

MAIFEST. One of the most anticipated events at the halls is the annual Maifest (Mayfest), the traditional German celebration of the arrival of spring. Maifest is still celebrated throughout Germany and in the German communities of Texas. It is the spring equivalent to Octoberfest. As most of the arriving Germans were farmers, they brought planting celebrations with them to Texas. Since the 1800s, Maifest and Octoberfest are still the two most celebrated events each year. Shown here is a 1915 celebration at Millheim Hall.

MILLHEIM HARMONIE HALL. Originally called Muehlheim, meaning "Home of the Mill," the town came into being in 1845. It was part of the original land granted to Stephen F. Austin in 1823 by the Spanish government. The original hall was built by the Millheim Harmonie Verein as a home for its German-heritage singing organization. It became a social center for many activities, including dances. A new hall, built in 1938, is still functioning and is home to many annual events. For barbecue aficionados, it is also known for its in-the-ground, open-pit style. The Millheim Harmonie Verein is located on FM 1088, just south of Bellville in Austin County.

18

MILLHEIM SINGING CLUB. These are the members of the Geisang Verein (singing society) from the Millheim area. Singing was very important to the Germans, as was beer, it seems. Many of the earliest breweries were of German origin, since brewing had been culturally entrenched for generations in Germany. The beer tradition in Texas (and in the United States) was radically influenced by Germans.

NELSONVILLE SPJST HALL. Nelsonville, nine miles west of Bellville in west central Austin County, is at the junction of State Highway 159 and Farm Road 2502. The area was first settled in the 1850s. Many of the early residents were German-speaking immigrants from Bohemia, who began to arrive in large numbers in the late 1860s and early 1870s and bought up much of the surrounding farmland. The original SPJST Hall was built in 1905. After it burned down, the present hall (shown here) was erected in 1925. It is now a private residence.

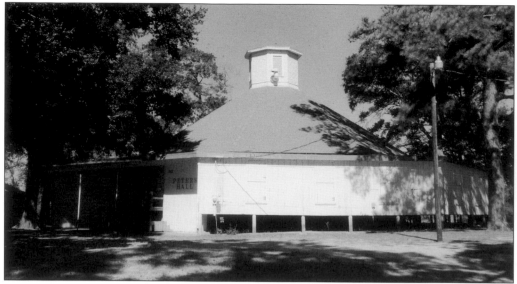

PETERS HACIENDA HALL. Peters, Texas, is on State Highway 36 and the Atchison, Topeka & Santa Fe Railway, five miles north of Sealy in southeastern Austin County. Anglo American settlement in the vicinity began in the mid-1820s. The Peters Hall (shown here) was built in 1900 by Joachim Hintz. The structure, a rare eight-sided hall, began as a Schuetzen Verein (shooting club), then operated as a community hall thereafter. It is the site of an annual Mother's Day celebration, barbecue, and dance, as well as private parties.

SEALY AMERICAN LEGION HALL. As the 20th century progressed, American Legion chapters proliferated as soldiers returned home from wars abroad. The new, modern Legion halls were often used for the still-prevalent dance culture in Texas at that time, and they also precipitated the demise of some earlier halls.

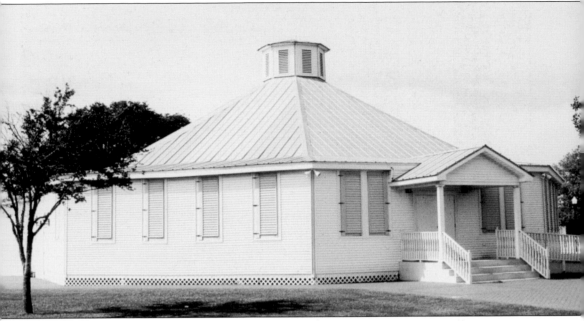

SEALY LIEDERTAFEL. A Liedertafel is a society or club dedicated to the practice of male part songs. In Sealy in the 1890s, one such group was formed, and it built a hall. In 1914, Ferdinand Lux and Marcus Kinkler decided to construct the octagonal hall shown here. It was used for dances and barbecues (the pits, dug deep in the ground, are behind the hall). A pavilion in front was also the spot for brass-band performances and speeches.

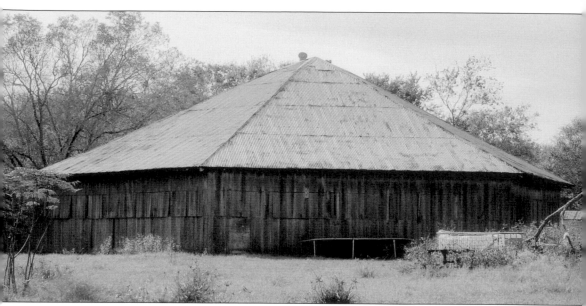

MIXVILLE SUNRISE HALL. This hall is now located at County Road 131 (Mixville Road), just off State Road 36 south of Sealy, Texas, in Austin County. The land was purchased by Joe and Amalie Pavlicek, who built the structure in 1928 on the site of a former dance platform. Now on private land, the hall is being used for storage. This rare six-sided hall is one of only a handful of documented round-sided halls. Among early bands that played here are Rambler's String Band and Sablatura's Famous Orchestra of Ganado.

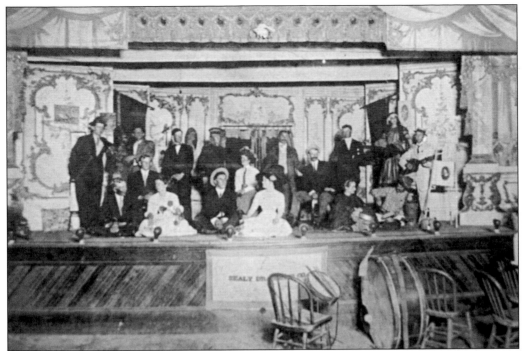

SEALY OPERA HALL, INTERIOR. A traveling stage company is seen in the Sealy Opera Hall in 1923. Note the wooden floor used for dancing, as the early opera halls were multi-functional venues. The raised stage has plenty of room for bands, theatrical performances, and other community functions.

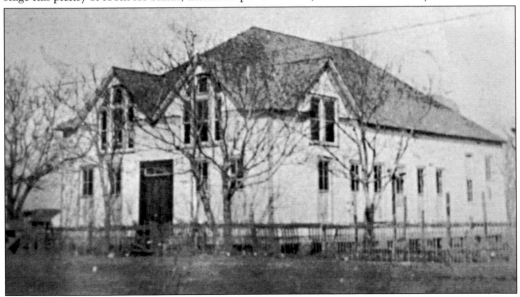

SEALY OPERA HALL. Sealy is at the junction of two railroads, the Missouri, Kansas & Texas and the Atchison, Topeka & Santa Fe, and at State Highway 36 and Interstate 10, four miles southwest of San Felipe in southeastern Austin County. Anglo American settlement in the vicinity began in the early 1820s, when San Felipe de Austin, soon to become the capital of Stephen F. Austin's colony, was founded on the west bank of the Brazos River a few miles to the northeast. This photograph of the Sealy Opera Hall dates to 1900.

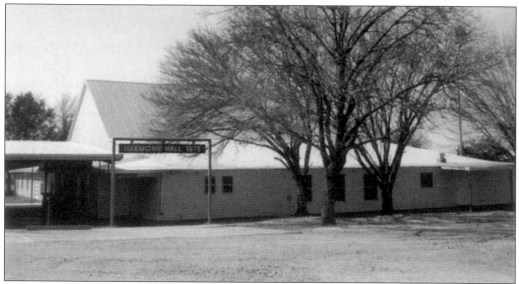

SHELBY HARMONIE VEREIN. Most of the early residents of Shelby were members of the German Adelsverein (emigration organization). The Shelby Harmonie Verein (singing club) was established in 1875. The hall, built in 1883 by Oswald Palm, soon became the center of social life in Shelby. The Sons of Hermann still meet here monthly. Many changes have been made over the years, including the installation of air conditioning. Located 24 miles northwest of Bellville in extreme northwestern Austin County, Shelby is at the junction of Farm Roads 389 and 1457.

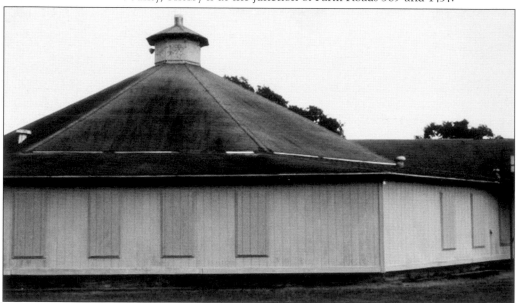

WALLIS AMERICAN LEGION HALL. Wallis is at the junction of the Southern Pacific Railroad and the Atchison, Topeka & Santa Fe Railroad, 10 miles southeast of Sealy in extreme southeastern Austin County. Anglo American settlement on the narrow strip of land west of the Brazos River and east of the San Bernard River started in the late 1830s. Beginning around 1890, a number of Czech immigrants took up residence in the area, coming from Fayette County. This eight-sided American Legion hall is located at 330 Legion Road in Wallis, Texas. The hall, built in 1937, replaced the popular Bernard River Platform just south of town.

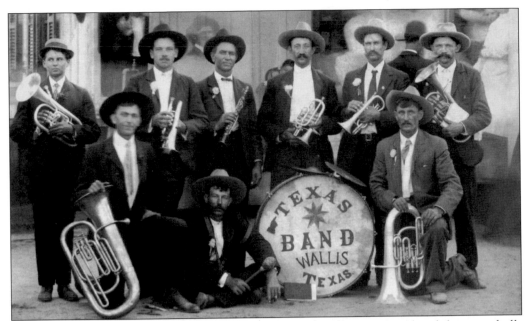

THE TEXAS BAND. This was another of the fine German brass bands that played the many halls in and around Austin County. Many of these were family bands or had multiple members with the same last name. Brass bands numbered in the hundreds in Texas's early period, and they had a profound effect on the swing and big bands to follow.

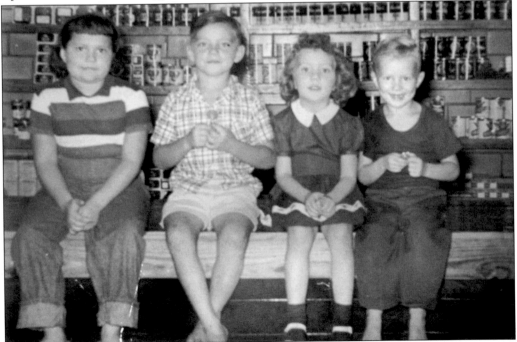

CHILDREN AT A DANCE. The festivities were always family affairs at the halls. Many memories have been told of children sleeping on benches while the older generation continued to dance. Some halls even provided "crying rooms," where the children could be put down to sleep in a common area. (Courtesy of Nat's in Milano.)

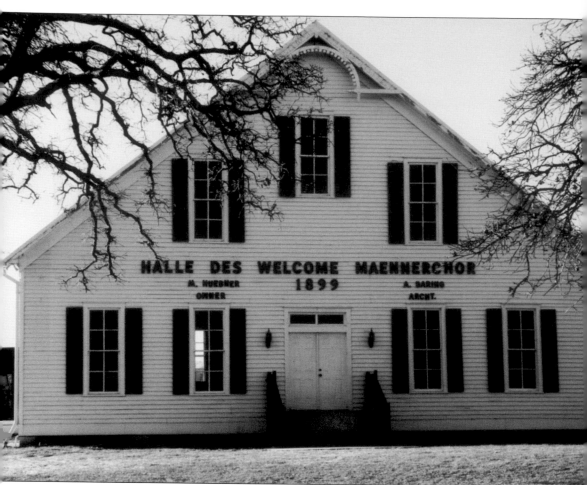

WELCOME HALL. The German singing group Welcome Mannerchor was established in 1887 and built this hall in 1899, originally in the small town of Welcome, just north of Industry. Serving as the social center of the community, the group chose as its goal the cultivation of the German language, German folk song, and German sociability. The building was home for Welcome Mannerchor's many singing activities and other events, including Saturday night dances. The hall went dormant in later years and was acquired in 1980, then moved to Industry and restored. The hall is located just north of Industry on the west side of Highway 109.

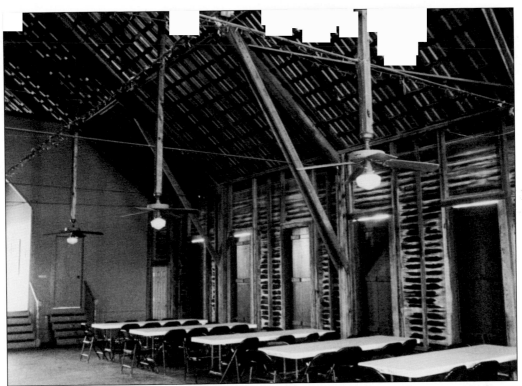

WELCOME HALL, INTERIOR. This is an interior photograph of Welcome Hall, now near Industry. Few renovations have been made, in order to keep the building's architectural integrity and historic nature intact. Visible here is the weather-stained patina on the clapboards.

BELLVILLE TURNVEREIN. This interior photograph of the Bellville Hall shows the prominent center pole. During dances in many of the early round halls, the men would gather around the pole, while the ladies sat on benches alongside the walls, waiting to be asked to dance. The center poles provided the main support for the complicated roofing structures. (Courtesy of Krista Whitson.)

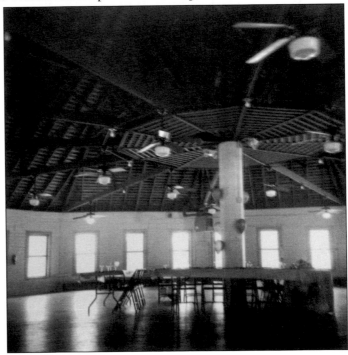

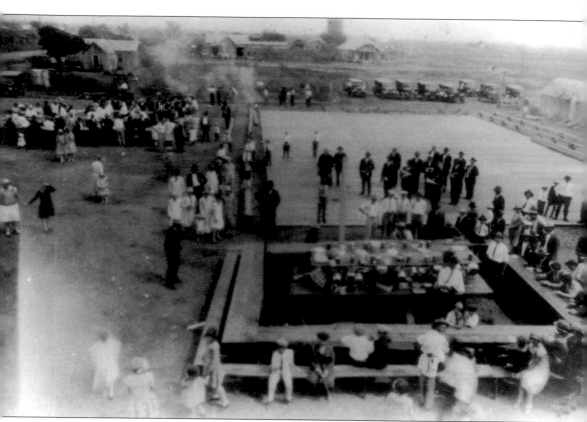

WALLIS PLATFORM. At this dance in Wallis in 1920, the Micak Brass Band of Frydek is performing. Note the in-the-ground barbecue pits, where all the food was cooked. This celebration was organized by the local Catholic church. (Courtesy of Dance Halls of Austin County.)

Two

COLORADO COUNTY

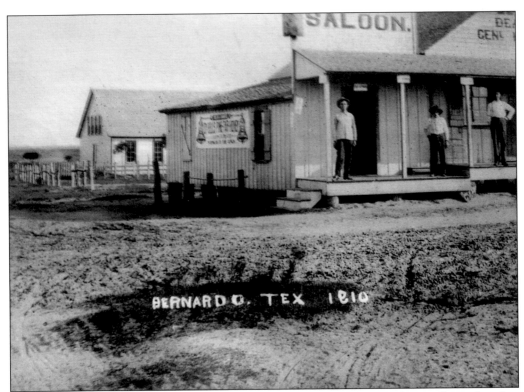

BERNARDO HALL. In this photograph of early Bernardo, the saloon and general merchandise store are in front, and the dance hall is in the rear. Dance halls were important to commerce and community, as they were very often one of the earliest buildings to be erected in town. (Courtesy of Carl Sebesta and the Bernardo Farm & Ranch Store.)

COLUMBUS PARK AND PLATFORM. Columbus Park was the earliest area in Colorado County for community celebrations. This is where the early Volkfests were performed. The area was often called The Grove. Volkfests, early German festivals in Texas, included a gathering of singing societies. The park and dance platform were located near the Colorado River in a natural clearing that is still a park today.

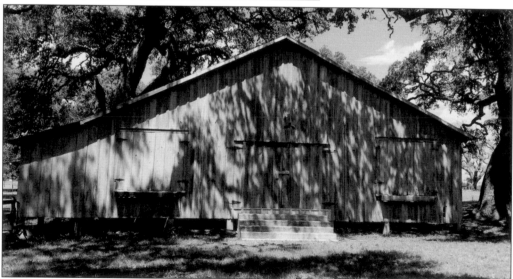

SCHNEIDER HALL. The Schneider brothers purchased the land on which the dance hall stands at the beginning of 1925. They built the white house that still stands on the hill in 1926, where they lived with their parents, Charles W. (a German immigrant) and Caroline Schneider. The dance hall, originally a barn for cotton storage, did not host entertainment until 1931. The Schneider brothers would hold dances not only on Saturday night, but often during the week and on Sunday. Martha, their sister, cooked hamburgers in the soda joint, which was located just outside the front steps of the hall. The hall closed in 1941 at the onset of World War II, and the brothers entered the war. It has recently been lovingly restored.

ILSE BAND. This group was one of the early Czech bands that performed in the many Czech and German halls around East Central Texas. What isn't typical is the band's instrumentation, particularly the dulcimer. Although the dulcimer was known in Czech music and was well documented with the legendary Baca Band from Fayetteville, it was still quite rare for most bands.

MENTZ HALL. The town of Mentz is at the intersection of Mentz and Frelsburg Roads, seven miles northeast of Columbus in Colorado County. The community was settled around 1846, primarily by German Catholics from Büdesheim, Hesse. This photograph depicts the Burttschell family leaving for Seguin after a wedding and reception at the hall in 1909.

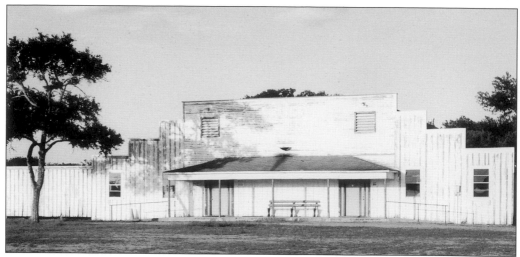

NADA HALL. Nada is on State Highway 71 in southern Colorado County. Nada Hall is off to the east about 200 yards, as the town's businesses were moved when the new highway was built. The original name of the town was Vox Populi (from Latin *vox populi vox dei*, "the voice of the people is the voice of God"); the present name is an American version of the Czech word *najda* (hope). There was a dance hall in Nada by 1904. A new hall (shown here) was built around 1924 by the local community, to serve as a KJT (Czech Catholic club) Hall. It is owned by the local church and is still in use for many festivities.

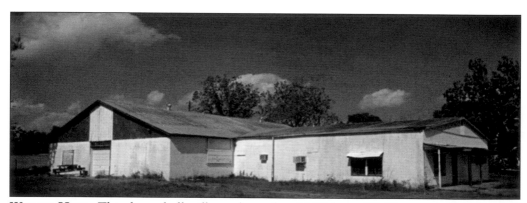

WEIMER HALL. This dance hall still stands on the old Highway 90. The interstate has taken most of the business farther south, and the hall is now abandoned. Highway 90 was a busy commercial route and an important musical link between San Antonio, Houston, and Louisiana, and many empty remnants of the bygone era are still visible. A great extent of Texas's musical cross-pollination happened along Highway 90 in the 1950s and 1960s. The era brought together rock 'n' roll, cajun, zydeco, swamp pop, Tex-Mex, and hillbilly styles, and bands started to perform interracially for the first time.

Three

DeWitt County

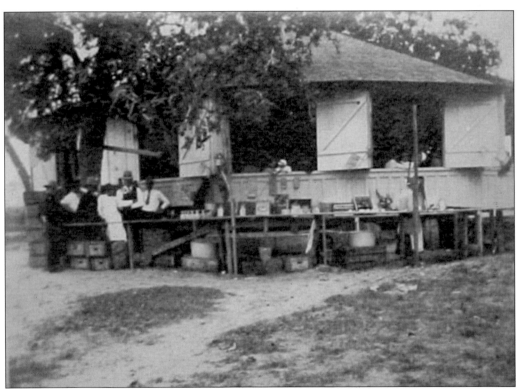

Arneckeville Dance Hall. The community eight miles south of Cuero on Farm Road 236 was first called Zionsville, then 5 Mile Coletto, and finally Arneckeville, in honor of Adam Christopher Henry Arneckeville, who settled there in 1858. Herman Grunswald owned the hall for three years, and held dances every two weeks. Charles Koenig purchased the dance hall in 1928, tore it down, and moved it to Cuero to build the Red Arrow Freight building on Broadway Street. That building was torn down in September 2007 to make way for the new DeWitt County jail.

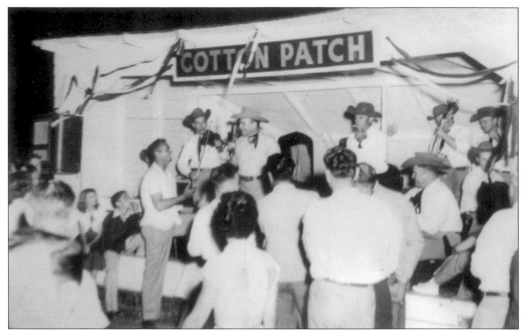

BOB WILLS AT COTTON PATCH. The rural settlement of Cotton Patch is located near the junction of Farm Roads 2656 and 952, about 21 miles west of Cuero in western DeWitt County. This is a rare photograph of Bob Wills and His Texas Playboys performing at the outdoor platform. Many rural communities, lacking dance halls, had only platforms to serve for dances. In some cases, walls were later added. (Courtesy of Mike and Ester Puente.)

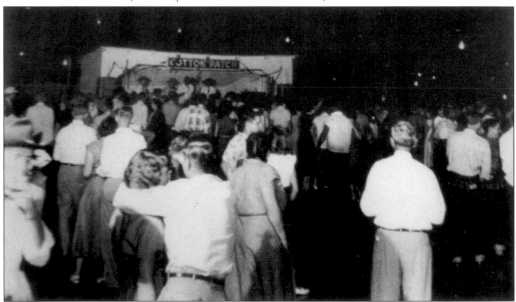

COTTON PATCH PLATFORM. The Cotton Patch platform was also a store where neighbors could pick up supplies and drink beer on their way home. The dance platform was popular, and many regional attractions played there, including The Texas Top Hands, Burg Morisse & His Star Dust Orchestra, and the legendary Bob Wills. The store and platform have recently reopened. (Courtesy of Mike and Ester Puente.)

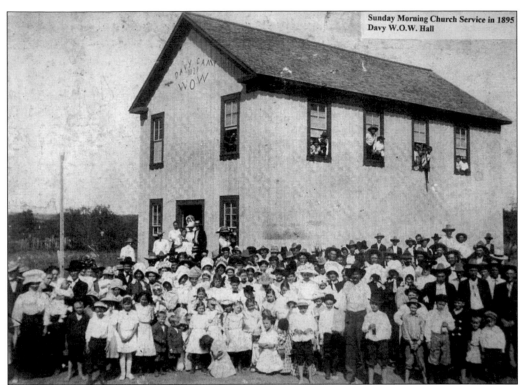

DAVY WOW HALL. Davy is a farming community in northwestern DeWitt County near the Karnes County line. Davy WOW (Woodmen of the World) Hall was a two-story structure built in the late 1800s. It has been said that John Wesley Hardin's father, a circuit preacher, would perform services at the WOW Hall. It was used for community activities, dances, revivals, and funerals. (Courtesy of Robert Muschalek.)

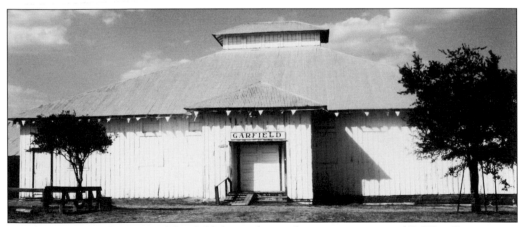

GARFIELD HALL. The town of Garfield, located near the western corner of DeWitt County, was named after Pres. James A. Garfield. The Garfield Gun Club was started in 1892, and a dance hall was built. In 1910, a new hall (shown here) was erected. The popular annual sausage festival and other yearly events are still held in the beautiful antique hall, which has undergone little or no remodeling, keeping its architectural integrity intact. Garfield is on Farm Road 2656, ten miles west of Yorktown.

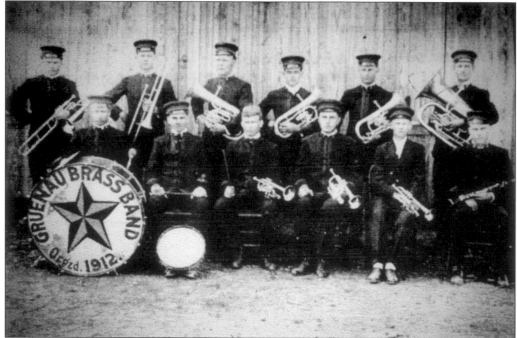

GRUENAU BRASS BAND. The year was 1914, and the Gruenau Brass Band was expanded to 12 men. Here, the band poses in front of Gruenau Hall. From left to right are (first row) Otto Lamprecht, Osmar Audilet, Emil Seifert, Joe Richter, Fritz Peters, and Oswald Seifert; (second row) Eddie Seifert, Herman Peters, Otto Seifert, Caesar Metting, Gus Seifert, and Dick Lamprecht. (Courtesy of Yorktown Historical Museum.)

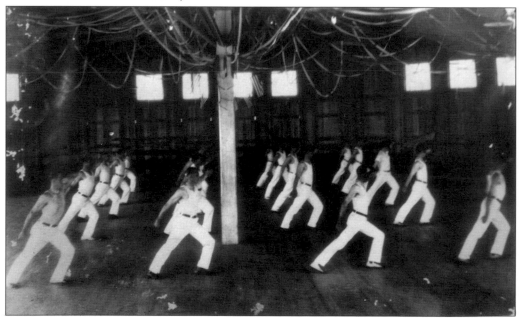

GRUENAU HALL, INTERIOR. In Gruenau Hall boys are practicing for an exhibition, under the direction of Edo Hoepkin. The hall was used for many Turnverein activities. (Courtesy of Yorktown Historical Museum.)

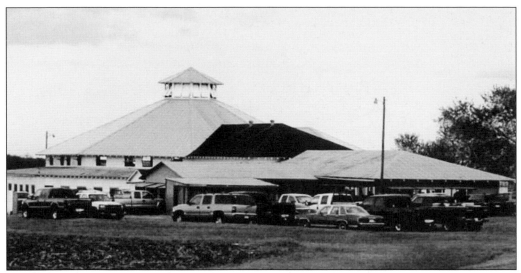

CELEBRATION AT GRUENAU HALL. This is Gruenau Turnverein Hall during one of its annual celebrations, just a few years before it tragically burned down. Beginning in the 1880s, the turnvereins, whose primary function was gymnastics, began to disband or merge with other organizations. Many clubs changed their function, becoming merely dance hall sponsors. Other halls retained bowling as a major focus. The Texas Turnverein Bowling League was established in 1913. At present, five of the six Texas turnvereins own bowling alleys and sponsor leagues.

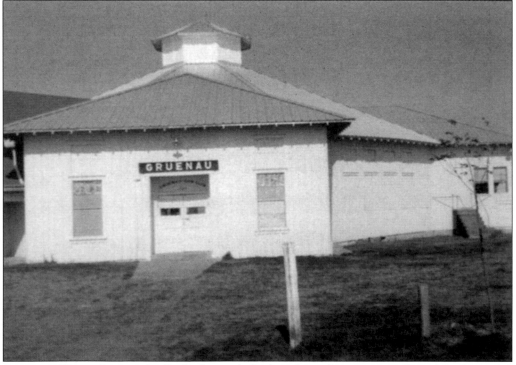

GRUENAU HALL. Gruenau Hall, the front of which is shown here, was another of the beautiful, multi-sided halls that were found in very few numbers. This building tragically burned down in 2007. It has been rebuilt, although in a more modern style.

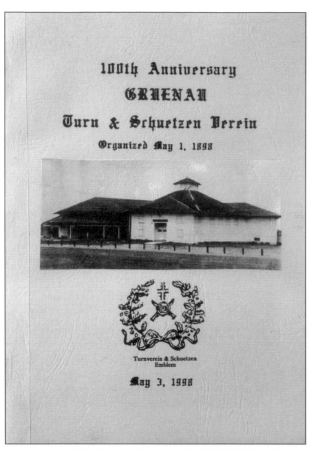

GRUENAU HALL BOOKLET. This is the Gruenau Schuetzen Verein Hall 100th anniversary booklet, published in 1998. These were sold to commemorate the hall's first century and to raise money for the ongoing upkeep of the hall. Note the "Turnverein & Schuetzen" emblem on the front of the booklet, indicating allegiance to the German clubs.

IMPERIAL ACES. Seen here in the late 1920s or early 1930s, the Imperial Aces was an area band that exemplifies the transition of many bands to the popular big band and swing style that was gaining in popularity. During this time, the earlier Czech and German cultures began to acculturate to the changing tastes and the progression of popular music. (Courtesy of Yorktown Historical Museum.)

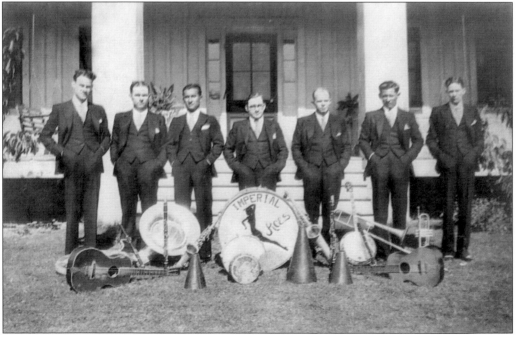

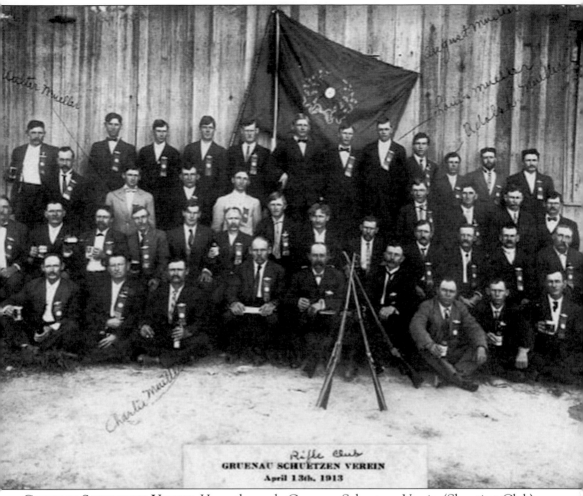

GRUENAU SCHUETZEN VEREIN. Here, the early Gruenau Schuetzen Verein (Shooting Club) poses in front of Gruenau Hall around 1913. Gruenau is a German community eight miles from Yorktown in northwestern DeWitt County, just west of FM 108 on Gruenau Road. The Gruenau Scuetzen Verein was established in 1897, and the present hall dates from 1927, when the original Verein building was demolished. Schuetzen Verein celebrated German culture by hosting feasts and dances and by the crowning of a Schuetzen-Koenig, or king of the riflemen. (Courtesy of Yorktown Historical Museum.)

SONS OF HERMANN HALL. The town of Hochheim is at the intersection of US Highway 183 and State Highway 111 in northeastern DeWitt County. Its name may be translated as "Hoch's Home" or "High Home." In 1895, half of Hochheim's population was German. The Order of the Sons of Hermann (also known as Hermann Sons) was the largest fraternal insurance benefit society headquartered in Texas. The mission of the brotherhood was to provide aid to the sick and to widows and orphans, and to help provide financial protection to its members and their families.

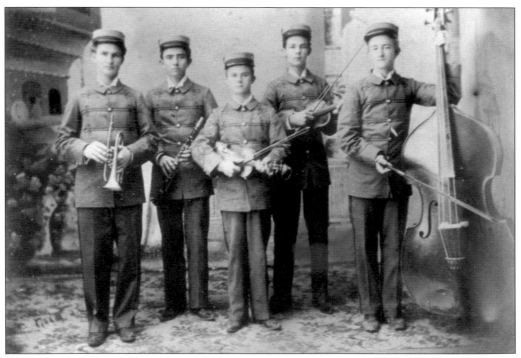

IDEAL BAND. This 1895 photograph shows the Ideal Band, the first brass band from Yorktown. It was together for over 30 years. On occasion, its members included many of the city's officials, such as the mayor, postmaster, city marshal, a tavern keeper (of course), and a bookkeeper. (Courtesy of Yorktown Historical Museum.)

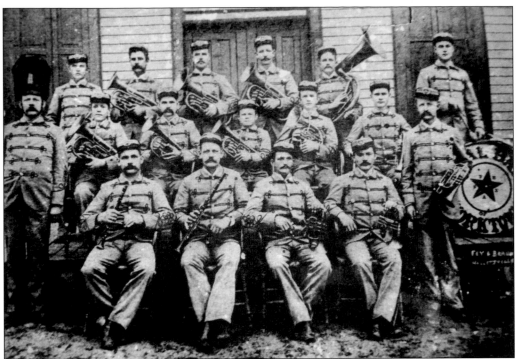

EXPANDED IDEAL BAND. This is another photograph of the Ideal Band, also called the Yorktown Ideal Band. This may be a later photograph than the previous one. As the town grew, so possibly did the band. Many German immigrants traveled the Old Indianola Trail, settling here and influencing the town's music and culture significantly. (Courtesy of Yorktown Historical Museum.)

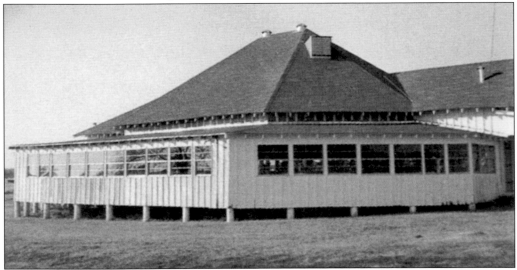

LINDENAU SCHUETZEN VEREIN HALL. Germans settled the town of Lindenau in 1891. The German men of the community organized the Lindenau Schuetzen Verein in 1901, now the Lindenau Shooting Club. They built a long building and called it a hall. By May 1926, a new hall was constructed. In 2014 the hall remains active, with dances on weekends and feasts featuring the popular homemade sausage, cooked in big kettles for major events such as May Fest. Lindenau is on Farm Road 953, five miles northwest of Cuero in north central DeWitt County.

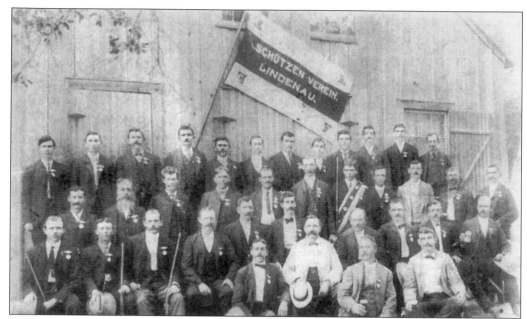

LINDENAU SCHUETZEN VEREIN. Schuetzen Verein members pose in front of the first hall built in Lindenau, which was also used for shooting matches. When the town moved because of the railroad, the hall was relocated too. It was later replaced by the present hall, called Lindenau Rifle Club Hall.

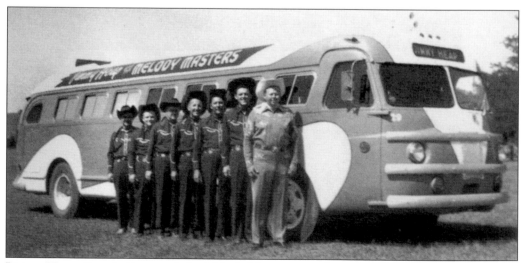

JIMMIE HEAP. Jimmie Heap and the Melody Masters were formed in Taylor, Texas, in 1946. A hugely popular band, they toured nationally during their 30 years, playing many of the historic dance halls in Texas, including in DeWitt County. Jimmie Heap had several hits that later became country music standards, including "Wild Side of Life" and "Release Me."

LITTLE MILWAUKEE CONCERT POSTER. Little Milwaukee was a DeWitt County community located one mile south of Yorktown, an area settled mostly by Germans. Herman Gruenewald opened a dance hall that became known as Little Milwaukee. The site was abandoned by 1962. (Courtesy of Yorktown Historical Museum.)

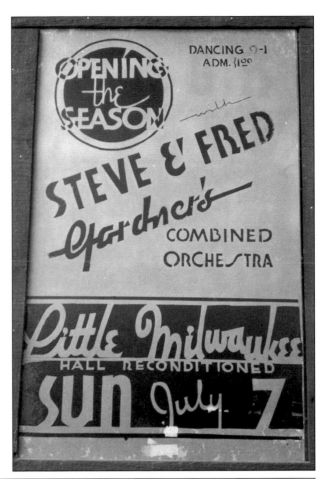

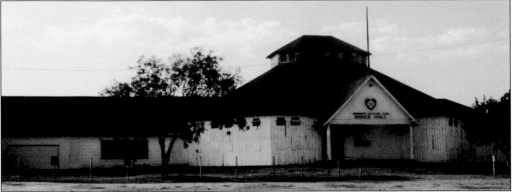

NORDHEIM SCHUETZEN VEREIN. The town of Nordheim, seven miles west of Yorktown in western DeWitt County, is a German community that was established in 1895 as a siding, known as Weldon Switch, on the San Antonio & Aransas Pass Railway. This is a photograph of one of the most visually remarkable halls in Central Texas. In 1908 the first hall was built, but by March 1939, the entire dance hall was razed and rebuilt with a more modern structure, but retaining the polygon design that is so overwhelming today. The German heritage that has characterized this small town is still evident. The Schuetzen Verein hall is still active as a social center, although shooting matches are no longer held.

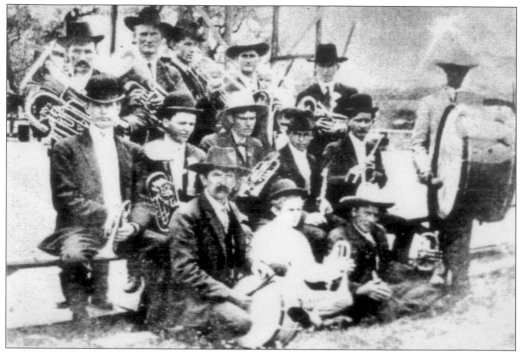

NORDHEIM BRASS BAND. Posing with the Nordheim Brass Band in 1898 is a young Alfred Zedler (front, center) on cornet, before he took control of the band. This ensemble, like many others in the area, lasted for many years. Family members would bring their children into bands as years passed. The Nordheim Brass Band lasted 75 years, finally disbanding in 1974. At that time, only two charter members were still living. (Courtesy of Yorktown Historical Museum.)

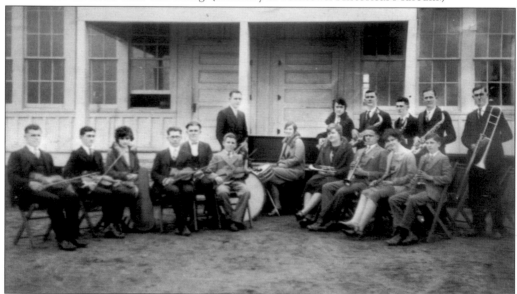

MEYERSVILLE COMMUNITY ORCHESTRA. Meyersville is the county's second-oldest German community. This is the Meyersville Community Orchestra, under the direction of Lou A. Sloma, in 1929. The town, just east of US Highway 183, is 14 miles south of Cuero in extreme southern DeWitt County. (Courtesy of Yorktown Museum.)

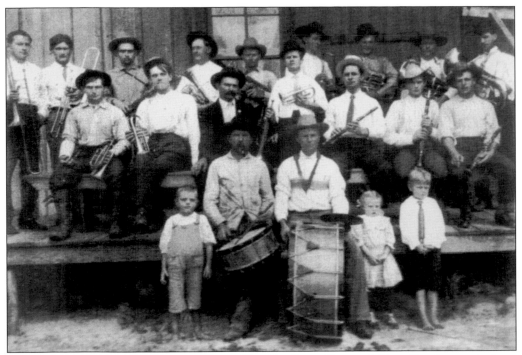

NORDHEIM BRASS BAND AND FIRST HALL. The Nordheim Fireman's Brass Band poses in front of the magnificent Nordheim Schuetzen Verein Hall sometime in the early 1900s. Alfred Zedler (1878–1938), the leader of the band, played cornet and, on occasions, most any other instrument as well. (Courtesy of Yorktown Historical Museum.)

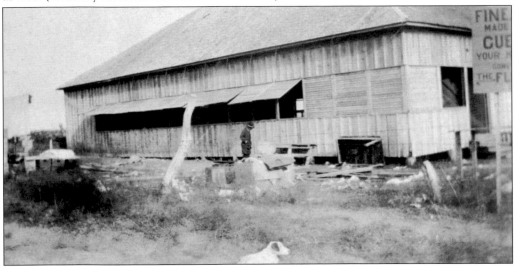

LENKE HALL. On October 19, 1910, Charles and Emma Lenke purchased five acres of land in Westhoff. Charles built a two-story home and this dance hall on the property sometime between 1910 and 1913. He was born in 1858 in the Thuringian region of Germany, in the small village of Luckenmuhle. He took violin lessons from his father, Carl. On October 20, 1873, Charles arrived at the port of Galveston at 15 years of age. In 1885 he met his future wife, Dorothea Louise Emma Ludtke, at a dance in the community of Star Hill in Austin County, where Charles was playing with a local band. In 1891, the Lenke family moved to Gruenau, near Yorktown.

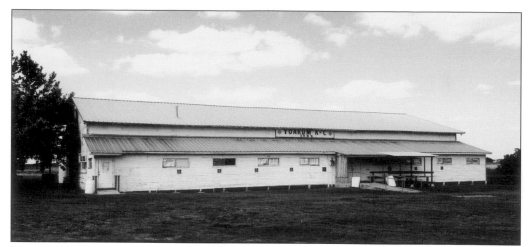

KNIGHTS OF COLUMBUS HALL. This hall is just west of Yoakum on Highway 111. The Knights of Columbus is the world's largest Catholic fraternal service organization. Originally serving as a mutual benefit society to low-income immigrant Catholics, the KCs developed into a fraternal service organization dedicated to providing charitable services. Many of its halls still have weekly or monthly dances.

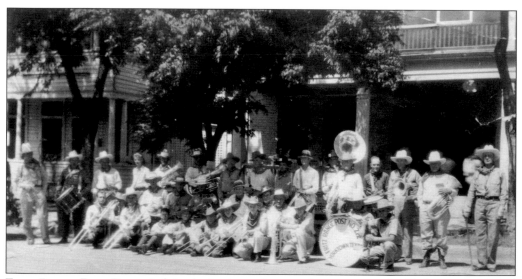

FRITZ RANGE POST BAND. Judging by its size and types of instruments, this Yorktown-area band was likely called on to perform in ceremonies of a civic nature. As with musical groups in most small communities, the band members would also form other, smaller ensembles to perform in local dance halls and play from an entirely different repertoire, one that was more suited for dancing. (Courtesy of Yorktown Historical Museum.)

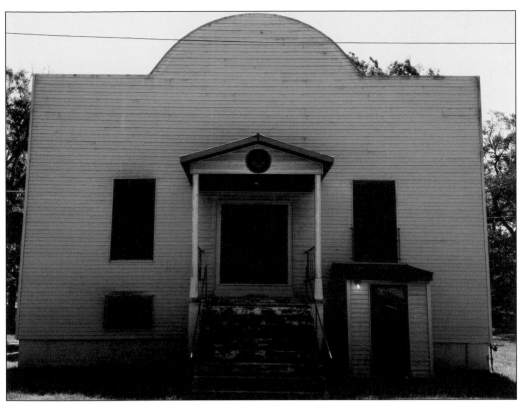

YORKTOWN SONS OF HERMANN HALL. The Order of the Sons of Hermann (also known as Hermann Sons) was the largest fraternal insurance benefit society headquartered in Texas. It was founded in San Antonio on July 6, 1861. In 1920, the Order of the Sons of Hermann in Texas, which by then was financially stronger and had more members than all of the lodges in the rest of the nation combined, broke away from the national order of the Sons of Hermann and became autonomous and independent. Originally, all of the members were of German extraction. This two-story hall has a dance floor on the upper level.

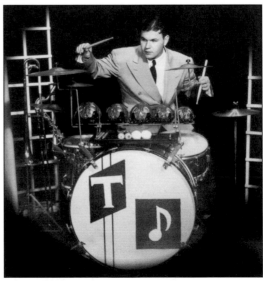

HAROLD "TEE" TIEMANN. A working drummer for 37 years, Tiemann led his own Tee Tiemann Orchestra for 23 years. He also owned and managed Tee's Music House in Yorktown, which later expanded to three additional locations. Tiemann played in most all of the dance halls in the area as well as at other area functions and well-known ballrooms, like the Rice Hotel in Houston. He also played for Adolf & the Gold Chain Bohemians, the Bill Cornelson Band, and the Lee Kohlenberg Orchestra. (Courtesy of Yorktown Museum.)

YORKTOWN COMMUNITY HALL. Yorktown is on State Highway 72 and Coleto Creek, 75 miles east of San Antonio and 36 miles northwest of Victoria, in southwestern DeWitt County. Many German immigrants traveled the Old Indianola Trail to settle here. The Yorktown Community Hall Association was organized in 1920, and shortly thereafter built a hall for its festivities. A new hall, shown here, was built in 1952 and still stands.

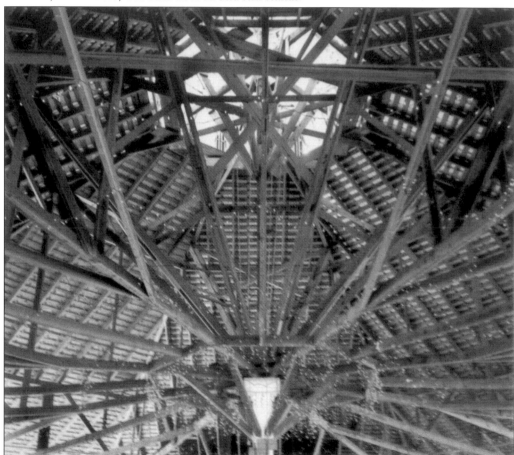

GRUENAU HALL ROOF. Shown here is the intricate roofing support for the 1927 Schuetzen Verein Hall. The roof was supported on a main center pole and the surrounding eight-sided construction. With open windows all the way around, and a high ceiling with cupola for airflow, the hall was a magnificent example of German construction and ingenuity. (Courtesy of Krista Whitson.)

Four

FAYETTE COUNTY

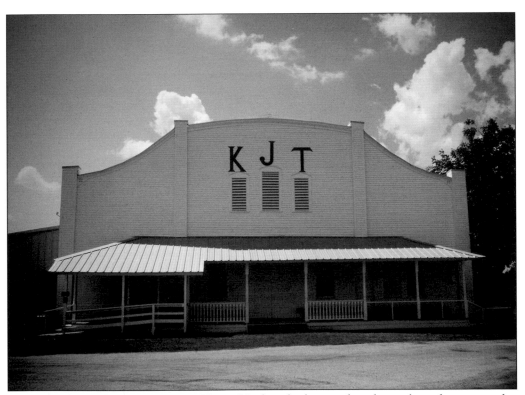

AMMANSVILLE KJT HALL. By 1877, Henry Hoelster had opened a saloon where the present-day KJT Hall is located. The property was eventually sold in 1923 to the KJT fraternal organization for its new lodge hall. It has been a great venue for a variety of social activities, primarily dances, which was the favorite form of entertainment for local German and Czech residents. Weddings, reunions, funeral dinners, and the annual church feast on Father's Day are still being held in the same hall. It stands next to the famous "painted church," St. John the Baptist, in the center of town. (Courtesy of Andrea Bohon.)

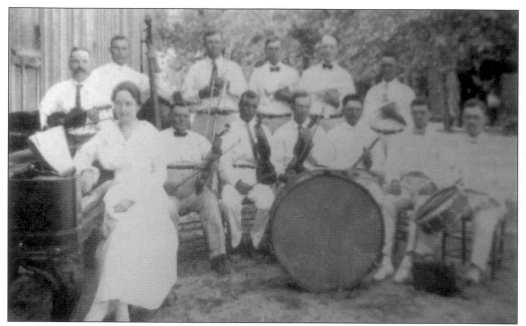

CARMINE ORCHESTRA. Shown here is an early iteration of the Carmine Orchestra. This photograph was most likely taken outside the local Carmine Hall or Cedar Creek Schuetzen Verein Hall. The band was family oriented, as were most small-town bands. The configuration shown here had two members of the Spies family and three members of the Braun family. (Courtesy of Elvera Korth Dallmeyer.)

CARMINE HALL. Carmine is on US Highway 290 at the Fayette-Washington County line. At one time called Cedar Creek Schutzen Verein and later Carmine Dance Hall, the building was erected in 1912. Carmine, Texas, was named for the first postmaster, Norman Carmean, around 1892. The hall is now used mostly for antique fairs and rentals.

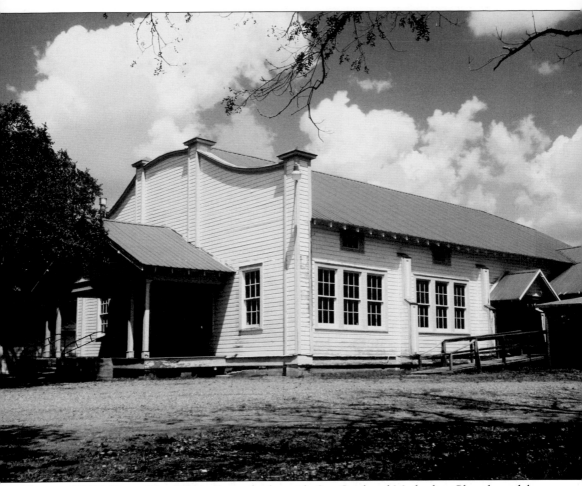

DUBINA KJZT HALL. The 1936 hall stands alongside Sts. Cyril and Methodius Church, widely known as one of the "Painted Churches of Fayette County." Founded in 1856, Dubina was established entirely by Czech Moravians and, as such, is accepted as the first Czech settlement in Texas. Dubina was listed in the National Register of Historic Places as a historic district in 2003. The hall is still the site of yearly celebrations of Czech customs, music, and food. (Courtesy of Andrea Bohon.)

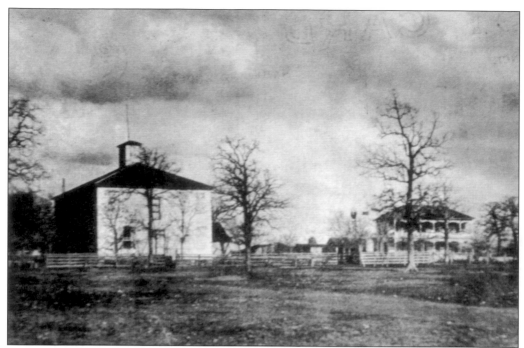

ELLINGER CSPS HALL. The CSPS (Czech-Slovak Protective Society) building, seen here on the left, housed the Czech School on the bottom floor. The upper level was used for meetings, dances, and community festivities. (Courtesy of Carolyn Meiners.)

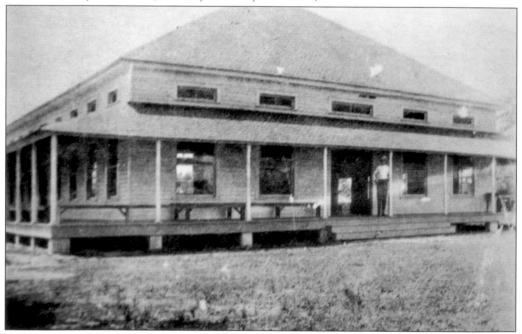

ELLINGER AUDITORIUM. Located 11 miles southeast of La Grange in eastern Fayette County, the town of Ellinger is at the intersection of State Highway 71 and Farm Road 2503. The Ellinger Auditorium (a former landmark) served as a dance hall as well as the location of many other recreational activities in earlier days. Standing on the porch is Emil Koehl.

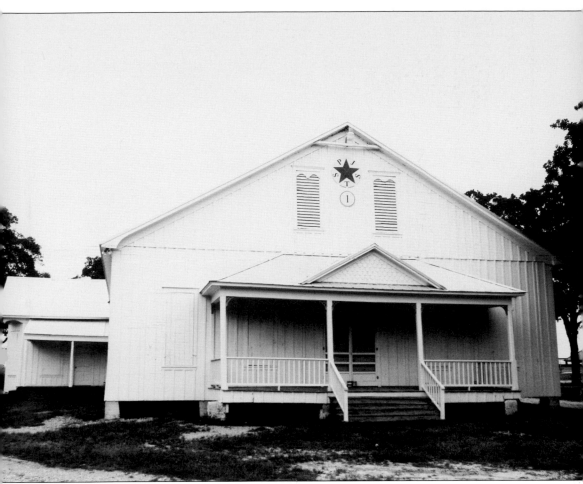

FAYETTEVILLE SPJST No. 1 Hall. This is the very first SPJST hall in Texas. The first SPJST lodge business was actually in the second story of the J.R. Kubena-Knesek Building, located on the northeast corner of the city square in Fayetteville. This hall was dedicated on October 2, 1910. It has had few changes over the years and still retains its open-air construction. The hall, situated north of town on County Road 159, is used for many occasions. This is how it looks today, the pride of Fayetteville, which has become a much-visited destination of late.

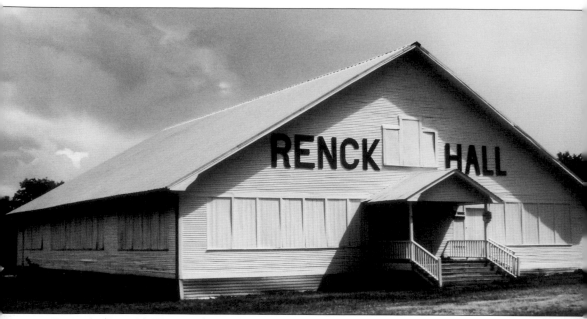

Renck's (Baca's) Hall. This is the former Baca's Hall, built in 1932 by Ray Baca, legendary bandleader of the New Deal Orchestra from Fayetteville. After many years hosting successful dances, it was sold to "Smokey" Renck and moved to Warrenton in 1992 as the site of a popular antiques fair. With a new paint job and a new name, the building has been host to thousands of shoppers in its new reincarnation.

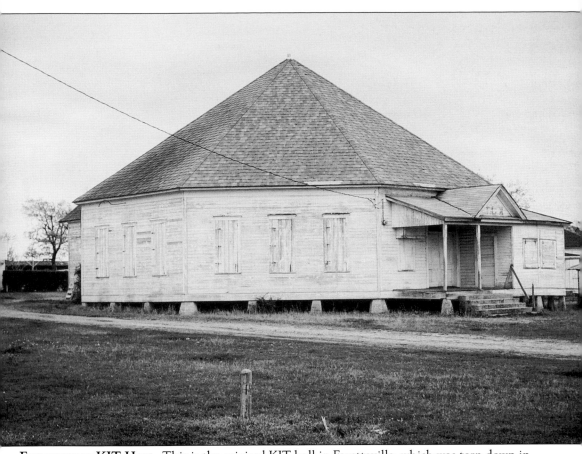

FAYETTEVILLE KJT HALL. This is the original KJT hall in Fayetteville, which was torn down in the late 1970s. It was one of the few unusual round halls built during the early period of Texas halls. It has been replaced with a small, metal, nondescript building that no longer hosts dances. (Courtesy of Roger Kolar.)

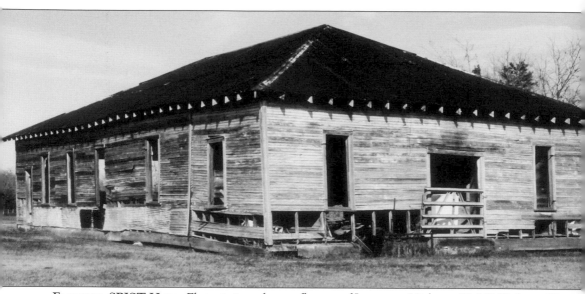

FLATONIA SPJST HALL. Flatonia is at the confluence of Interstate Highway 10, US Highway 90, and the main line of the Southern Pacific Railroad, 12 miles west of Schulenburg in southwestern Fayette County. Shown here is the long-abandoned Flatonia SPJST Hall on South LaGrange Street, along the railroad tracks on the southeast side of town, just past Elm Street. Unfortunately, many of these iconic halls are at risk today.

FLATONIA CONCERT POSTER. This is a very rare 1929 concert poster from the SPJST Hall in Flatonia. It advertises the dance sounds of the Machak Band, a popular early Czech polka band. The area was heavily populated with German and Czech people who swarmed to town after the railroad came in and offered inexpensive land for sale around the new community. Still each year, a weekend-long "Czhilispiel," a festival named by Czechs and Germans who like chili, attracts visitors from a wide area of Central Texas. (Courtesy of the E.A. Arnim Museum.)

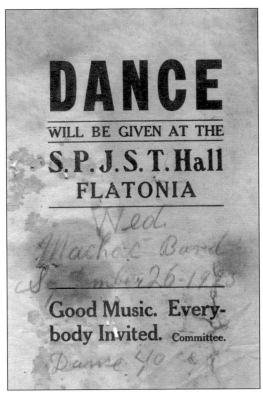

FAIR PARK PAVILION HALL. This is an aerial photograph of the Flatonia Fair and Fair Park Pavilion Hall. Originally the Flatonia Sons of Hermann Hall, the building later became the Fair Park Pavilion Hall. The Fair Park Association went bankrupt in the mid-1930s, and the building was soon after torn down. (Courtesy of Judy Pate and the E.A. Arnum Museum.)

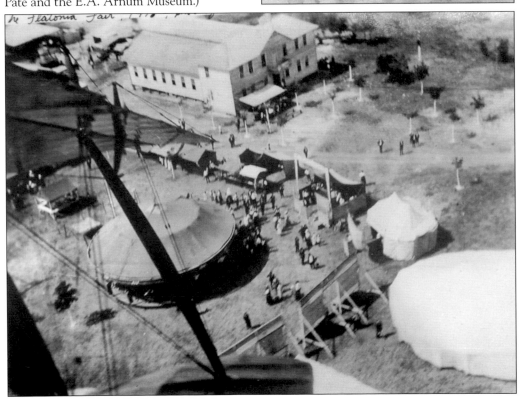

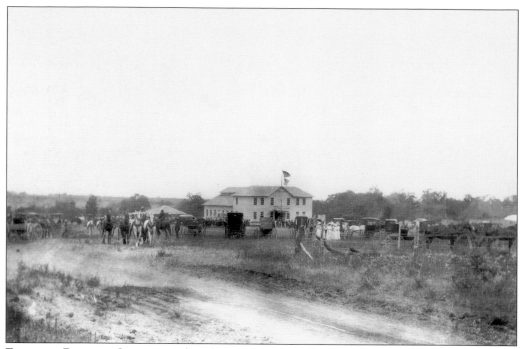

FLATONIA PAVILION GROUNDS. This photograph of the Flatonia Fair Park Pavilion Hall, taken from a distance, clearly shows the still-rugged dirt roads in the small community leading to the park area. (Courtesy of Judy Pate and the E.A. Arnim Museum.)

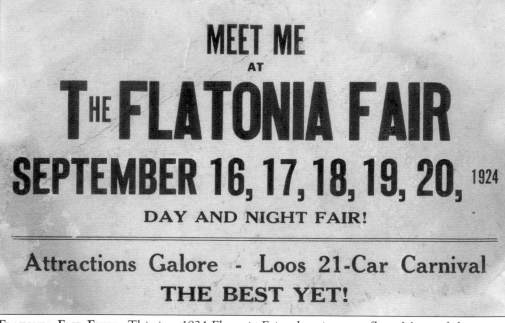

MEET ME
AT
THE FLATONIA FAIR
SEPTEMBER 16, 17, 18, 19, 20, 1924
DAY AND NIGHT FAIR!

Attractions Galore - Loos 21-Car Carnival
THE BEST YET!

FLATONIA FAIR FLYER. This is a 1924 Flatonia Fair advertisement flyer. Many of these area celebrations were supplemented by traveling amusement companies, which provided big rides and other attractions. Such fairs were part carnival, part zoo, and always ended with dances at night. (Courtesy of Judy Pate and E.A. Arnim Museum.)

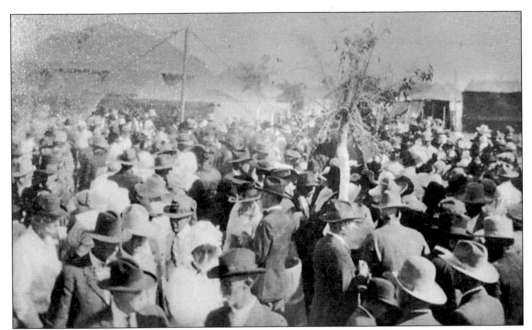

FLATONIA FAIR PARK CELEBRATION. This 1920s photograph shows crowds attending the Flatonia Fair. Fair Park Pavilion Hall, seen in the distance, was always the location of the many bands and dances for the week. Unfortunately, the large hall has been torn down. (Courtesy of Judy Pate and the E.A. Arnim Museum.)

FREYBURG HALL. Located at the intersection of Farm Roads 956 and 2238, the town of Freyburg is 12 miles southwest of La Grange in southwestern Fayette County. It was founded about 1868 by Germans and named for a town in Germany. The hall was originally called the Kaiser Frederich Parks Verein. Frank and Anton Beck built the hall in 1912, and it was owned by the Sons of Hermann until the 1970s, when the club had its last Mayfest, with an attendance of up to 4,000 people. The hall was then empty until 1994, when the Pettit family bought it from members of Hermann Hall. It is still open on special occasions.

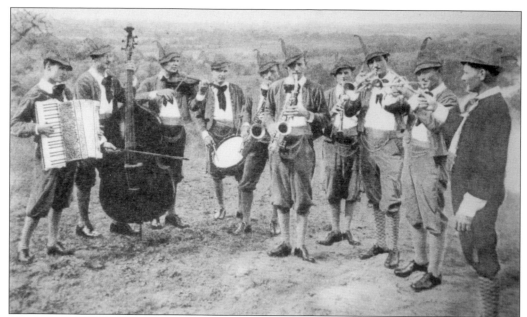

GOLD CHAIN BOHEMIANS. The Bohemians were also known as Adolf and the Boys. The band was sponsored by Gold Chain Flour, produced by University Mills in Dallas. The band's polka program was broadcast live from the Cozy Theater in Schulenburg every morning from 8:30 to 9:00 between 1935 and 1940. The Cozy Theater still remains as the only hotel (Von Minden) with a theater still in existence today in Texas. The theater still shows first-run movies on the weekends. (Courtesy of Mrs. John Luecke.)

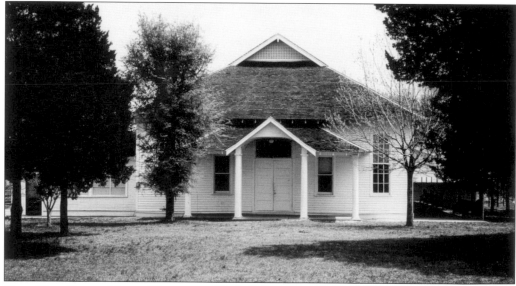

HIGH HILL PARISH HALL. The town of High Hill, on Farm Road 2672, is 14 miles southwest of La Grange in southwestern Fayette County. Predominantly a German settlement, it at one time had two dance halls and a brewery. This hall is owned by St. Mary's Catholic Church and is used frequently for community events, including dances and other ethnic celebrations. St. Mary's Church, one of the famous "Painted Churches," has recently undergone a major renovation. The church is also listed in the National Register of Historic Places.

HOSTYN CURTAIN. Hostyn overlooks the Colorado River near La Grange in central Fayette County. In the 1830s, the community, then called Bluff, was settled by Germans. Shown here is the 1920s Hostyn Parish Hall stage curtain. The hand-painted canvas curtain displays many of the local businesses. Such curtains were found in most of the dance halls, and a few still exist today. Many of them portrayed pastoral scenes or images reminiscent of the old country. (Courtesy of Fayette County Library.)

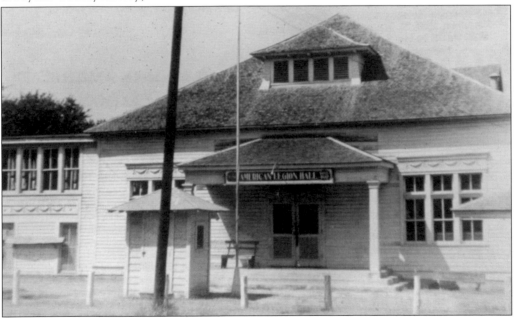

LA GRANGE AMERICAN LEGION HALL. This is the La Grange American Legion Post No. 102, organized in 1919 following World War I, and incorporated in 1939. The hall burned down in 1977 and was soon replaced with a newer building. Many dances are held to this day in the numerous American Legion halls across the state. (Courtesy of Fayette Public Library.)

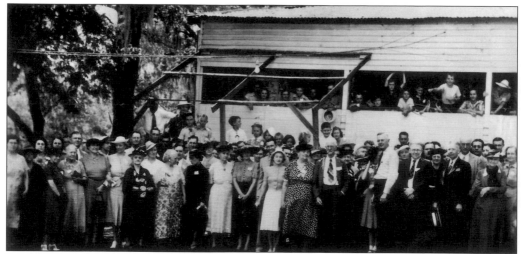

BLUFF SCHUETZEN VEREIN GATHERING. The town of Bluff is on the south side of the Colorado River, directly across from La Grange in central Fayette County. H.L. Kreische acquired the title to the top of the bluff about 1849 and began construction of his brewery next to the Scheutzen Verein Hall. The brewery for many years served as the focal point of the community. (Courtesy of Fayette County Library.)

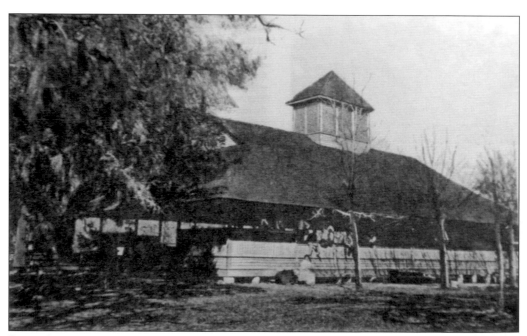

BLUFF SCHUETZEN VEREIN POSTCARD. Built by Heinrich Ludwig Kreische in the late 1860s and called Kreische's Bluff (also Bluff Shooting Club), this pavilion soon became the social center for the Bluff community overlooking La Grange. It was also the site of the remains of Texans killed in the Dawson Massacre and the Black Bean Death Lottery from 1847. (Courtesy of Fayette Public Library.)

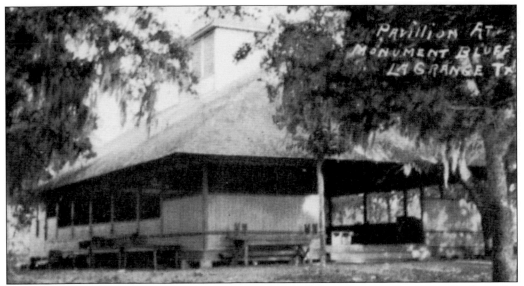

BLUFF PAVILION HALL. This photograph of the pavilion hall shows how it was open on all sides to the frequent breezes on the high hill overlooking La Grange. The site, just above the Colorado River, offers one of the most picturesque views in the whole county. (Courtesy of Fayette Public Library.)

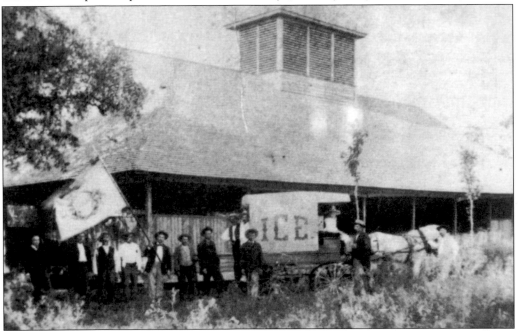

BLUFF SCHUETZEN VEREIN PAVILION HALL. The property where this hall was located is on a high bluff just west of US Highway 77 on an extension of Farm Road 155. The property is now home to the Monument Hill–Kreische Brewery State Historic Site. H.L. Kreische acquired the title to the top of the bluff in about 1849 and began construction of his brewery, which for many years served as the hub of the community. Also at that location was Bluff Beer, at one time one of the largest breweries in Texas. Remnants of the brewery, Kreische's historic home, and the 1936 Art Deco monument to the soldiers of the Dawson massacre remain on the property. (Courtesy of Fayette Public Library.)

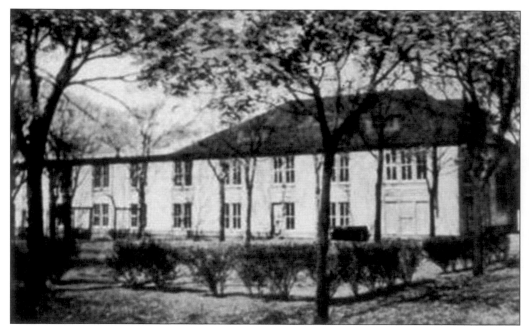

La Grange Casino Hall. The German Casino Hall (Club) was not a gambling hall, but rather a society hall or culture club. The hall, seen here in 1900, had monthly entertainment, usually a concert or an amateur play, followed by a dance or hop provided for the members. It also hosted fraternal functions for the members. The hall had a reputation as a social center, with its old German flavor and European traditions. (Courtesy of Fayette Public Library.)

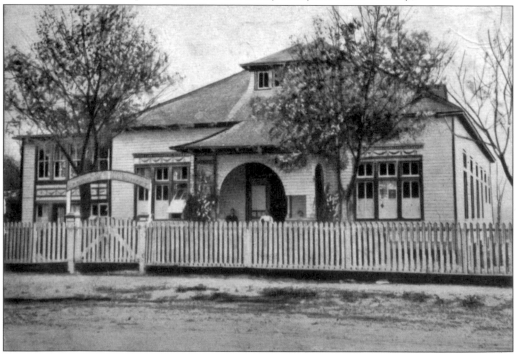

Casino Club. This photograph is from a 1901 postcard of the original Casino Club in Lagrange that was built in 1890. (Courtesy of Fayette Public Library.)

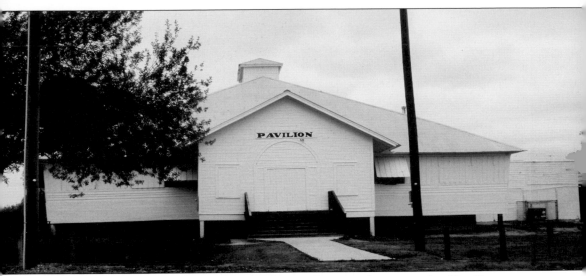

LA GRANGE PAVILION HALL. Located at the County Fairgrounds, just north of La Grange on Highway 77, the Fair Pavilion (Round Up Hall) was built in 1925. It stands beside the new Czech Heritage Center at the La Grange Fairgrounds and was recently the recipient of a face-lift.

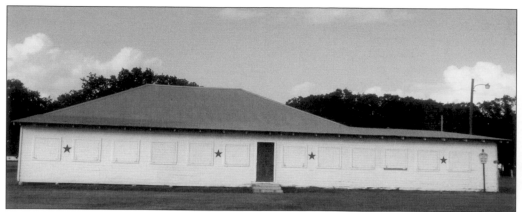

LEDBETTER FIREMAN'S PARK HALL. The hall is located on Labadie Street and Prospect Road in Ledbetter, one block north of Highway 290. The hall originally served as the school. In the 1940s, it was bought by the Fireman's Association and turned into a dance hall and community center. The town of Ledbetter is located eight miles east of Giddings and a mile north of Cummings Creek in extreme north Fayette County.

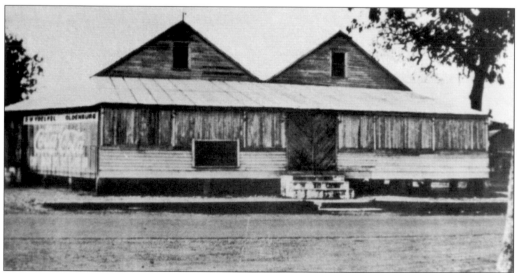

VOELKER HALL. Oldenburg, on State Highway 237, is seven miles northeast of La Grange in northeastern Fayette County. It was founded in 1886 and was named for the Oldenburg province in Germany, from which the settlers came. This hall, built around 1900 by R.W. Voelker, was one of two halls in Oldenburg (the other being Festplatz), none of which survive today.

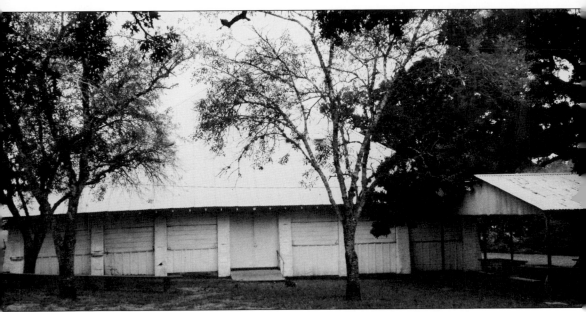

PLUM KJT HALL. Originally called Plum Grove, the town of Plum, Texas, is the second-oldest established community in Fayette County, having been settled in 1828. Its original settlers were Tennesseans. The Plum Baptist Church was the first Baptist church in Texas west of the Colorado River. The KJT Hall still stands and hosts annual events such as the popular Plum Sausage Festival in June. Plum is on State Highway 71 and the Missouri, Kansas & Texas Railroad, eight miles west of La Grange.

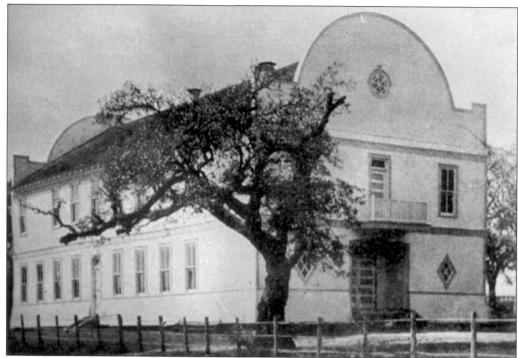

ORIGINAL PRAHA HALL. Since 1855, the community later named Praha has celebrated the Feast of the Assumption on August 15. The event now attracts more than 5,000 visitors, many of them Czechoslovakian. Mass is celebrated in the historic "painted" church, with its extraordinary interior painted by Godfrey Flury. This hall, built in 1912, no longer stands. (Courtesy of Roger Kolar.)

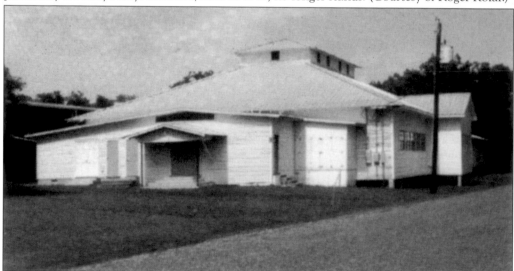

PRAHA PARISH HALL. In 1858, the town was renamed Praha, the Czech name for that country's capital, Prague. This hall, built in 1938, replaced the dance platform that dated to 1927. It still stands next to the historic St. Mary's "painted church," a spectacular Gothic structure that was completed in 1892 and is the center of the annual Feast of the Assumption homecoming festival. This festival has been celebrated in Praha each August 15 since 1855. Locally known as "Praha Picnic," the celebration draws as many as 5,000 visitors to its traditional Czech polka music and kolaches.

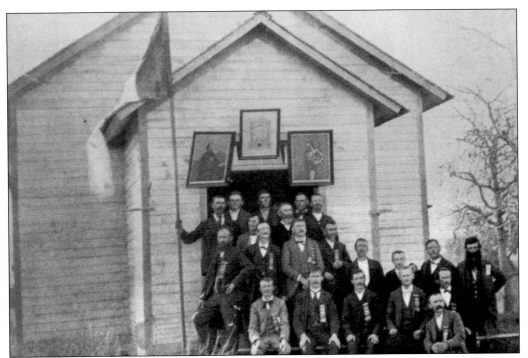

PRAHA CSPS HALL. This is the original CSPS No. 104, which later became the SPJST No. 11. In the 1880s, Czech pioneers in Texas joined other people of Czech descent in the United States in a fraternal benefit union called the CSPS, the Cesko-Slovanska Podporujici Spolecnost. One of the main purposes of the CSPS was to foster and preserve the Czech language in this new nation and to preserve the economic well-being of the settlers. As time passed, considerable discontent was expressed by members from Texas, and they broke away. On July 1, 1897, they formed the SPJST, the Slovanska Podporujici Jednota Statu Texas (Slavonic Benevolent Order of the State of Texas).

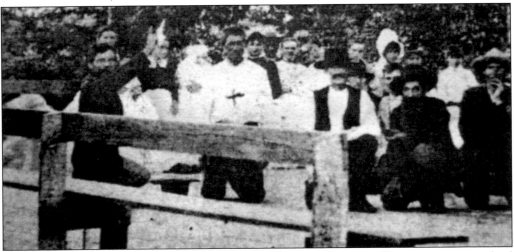

VYVJALA PLATFORM. Praha was earlier known as Mulberry, or Hottentot. The community revolved around the town square and included a resident physician, Dr. Taborcek, a post office in Knezek's general store, and another mercantile store. Praha also had two saloons, one owned by Joseph Vyvjala, who also owned a nice platform and hall for dancing. (Courtesy of Arnim Museum.)

AIRWAY PAVILION HALL. Built in the 1930s, Airway Pavilion Hall was originally in Wesley, Texas. It was moved to Round Top in the late 1990s to be used in the antique fair there. The hall is named Airway after its appearance; when the windows are raised, it looks ready for takeoff.

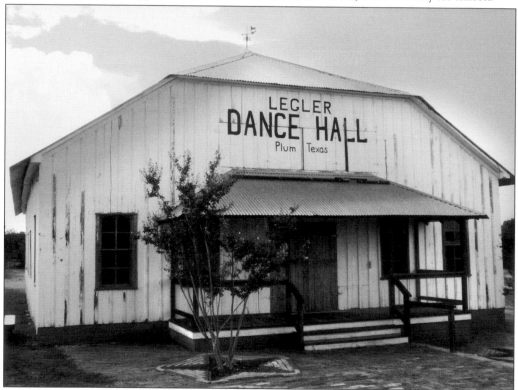

LEGLER HALL. This hall was built in 1890 near the railroad tracks in Plum, Texas. It was later moved to the Loop Road in Plum, and then to Round Top for the local antique fair. Legler Hall was a busy dance hall in the 1950s and 1960s, with regional favorites the Jesse James Boys from Austin playing every Thursday.

LEGLER HALL POSTER. This is an original blank performance poster from the 1950s for Legler Hall in Plum. Because of the large number of acts that performed there, the hall simply printed blank posters like this, then filled in the band name, admission price, and dates. These would be hung in the hall and distributed for display in store windows and other visible areas.

ROUND TOP SCHUETZEN VEREIN HALL. The Round Top Rifle Association Hall was built in 1912 and has been remodeled and expanded several times over the years. The club continues its annual Schuetzenfest as well as other events, including antique shows, the VFD Christmas dance, and the Firemen's Feast Fundraiser in May. Dances are also held on Easter and the Fourth of July. The Round Top Schützen Verein was formed in 1873 by the town's citizens of German descent. Its purpose was stated as the support and encouragement of bicycle riding, target and trap shooting, open air athletics, games, and of course, dancing. At one time, the site included the original hall, a bowling alley, a carousel, a saloon, and an ice-cream stand.

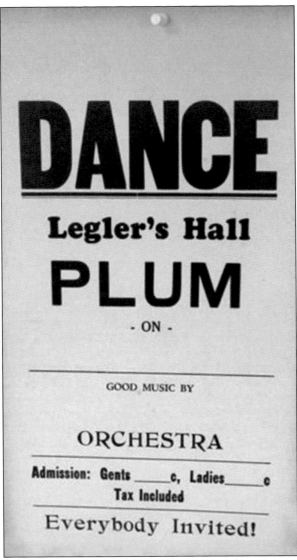

DANCE
Legler's Hall
PLUM
- ON -

GOOD MUSIC BY

ORCHESTRA

Admission: Gents _____c, Ladies_____c
Tax Included

Everybody Invited!

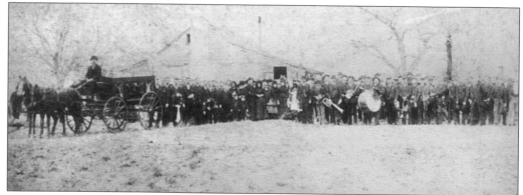

HIGH HILL BRASS BAND. This is a photograph of the High Hill Brass Band at the funeral cortege of Rudolf Russek on February 28, 1886. Rudolf Russek had been a member of the band. High Hill, an early settlement north of Schulenburg, refused the new railroad; most business therefore moved south to Schulenburg.

WESSELS HALL. Rutersville, on State Highway 159, is five miles east of La Grange in central Fayette County. It was founded by John Rabb and other members of the Methodist Episcopal Church for the purpose of establishing a college. Gerhard D. Wessels, one of the prominent businessmen of the area, had a saloon and dance hall located on the main road, now Highway 159. Both structures still stand today, but they haven't seen a dance in many years.

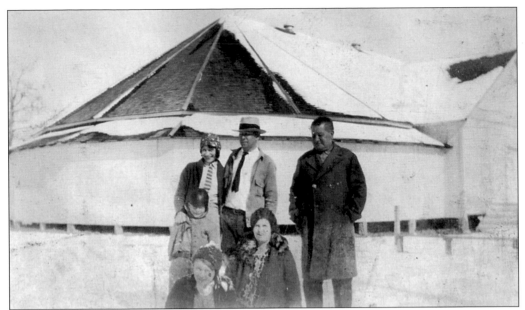

ERMIS HALL, WINTER. This photograph shows the little-known Ermis Hall, located on the west side of Schulenburg, where Highway 90 is now. The structure was an unusual round hall, and the builder is unknown. Posing in front of the hall are its owners, descendants of the Schumanns. The snow is unusual for that part of Texas. (Courtesy of Harold Schumann.)

ERMIS HALL, SPRING. Schumann youngsters enjoy the spring weather, with Ermis Hall behind them. The sign at right in the distance advertises camping, an unusual added attraction for a dance hall. Judging from this photograph, the hall was probably a 12-sided structure. It was enlarged with an addition to the far side. The detached building at center was most likely the concession stand. (Courtesy of Harold Schumann.)

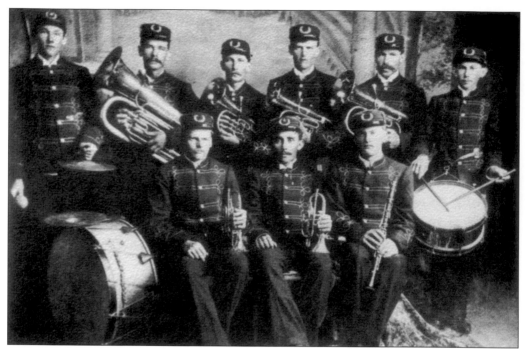

KNAPE BRASS BAND. The Knape Brass Band poses in a 1902 Herzik Studio photograph belonging to Erich Bauch. Shown are, from left to right, (first row) Louis Bauch, Henry Knape, and George Bauch; (second row) Edmond Strobel, Henry Sander, Fritz Thuemler, Herman Bauch, Paul Jaenichen, and Frank Knape. German brass bands played an important role in the social life of the communities. They played for parades, picnics, outdoor concerts, and most important, for dances.

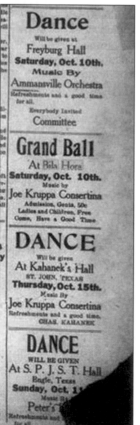

SCHULENBURG STICKER ADVERTISEMENT. This *Schulenburg Sticker* newspaper advertisement from October 9, 1925, shows how important dances and dance halls were in Texas's early days. This notice lists four shows in separate halls, Thursday through Sunday. Dance halls were the primary social outlet for the early communities.

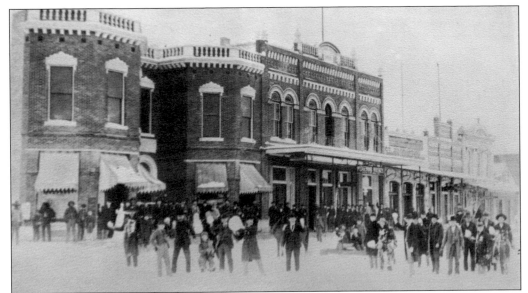

RUSSEK BUILDING AND SENGELMANN HALL. This is North Main Street in downtown Schulenburg in 1895. At left is the Russek Building, and at right is Sengelmann Hall. These were the two most prominent buildings on the north side, and they still stand today. The Russek Building is now the city hall. Sengelmann Hall, empty for years, has undergone a major renovation and now proudly contains a restaurant and a dance hall upstairs.

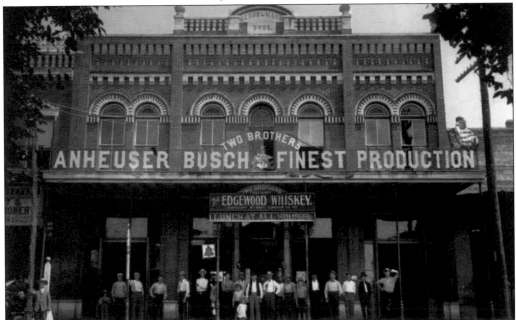

SENGELMANN HALL. One of the most prominent buildings on Main Street in Schulenburg, Sengelmann Hall was built soon after the railroad arrived. This is the second incarnation of Sengelmann Hall. The original structure, made of wood, burned down along with half of the downtown block in 1893. This new "Two Brothers" building was erected soon after the fire. The hall has been lovingly restored by Dana Harper and now features fine food downstairs and an original hardwood dance floor and a modern sound system upstairs.

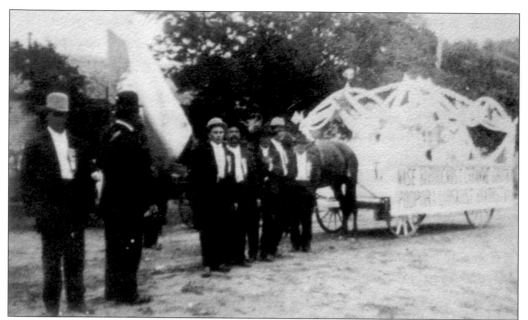

SPJST Float. An early SPJST parade float is seen in front of the hall. The sign on the float reads, in Czech, "In our future let us protect our orphans through the support of the Brotherhood of People." Between 1834 and 1900, approximately 200,000 people of Czech descent emigrated from their native lands to America. A good many of them ended up in Texas. SPJST started its operations on July 1, 1897, as the Slovanska Podporujici Jednota Statu Texas (Slavonic Benevolent Order of the State of Texas), with 782 members and 25 lodges.

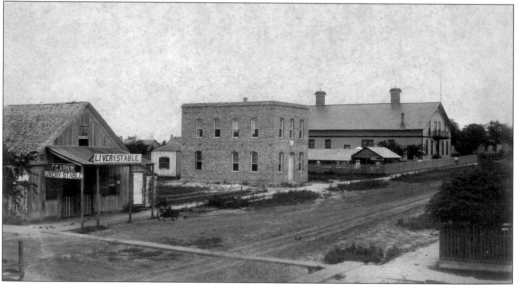

Schulenburg Buildings. The buildings shown here along Upton Avenue are, from left to right, the F.C. Arnim Livery Stable, an unidentified building, and the Turner Hall, at its original location before it was moved in the 1930s. Besides serving as physical education, social, political, and cultural organizations for German immigrants, Turner clubs were also active in the American public education and labor movements. This photograph was taken around 1906. (Courtesy of Fayette County Library.)

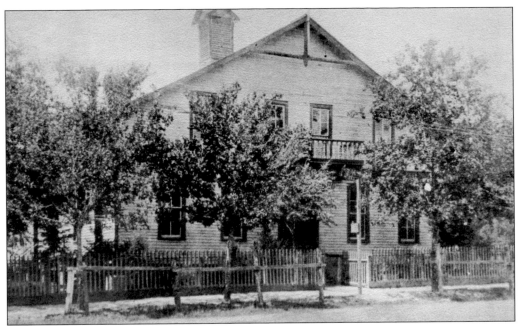

SCHULENBURG TURNER HALL. This is the 1886 Turner Hall, built on the corner of Upton Avenue and Summit Street. In the 1930s, it was moved on log rollers several blocks to the city park. This photograph is from the local Herzik Studios in Schulenburg. Reflecting changes in ownership and use, the hall has been called the Schulenburg Turnverein or Athletic Club, Turner Hall, Wolters Hall, Opera House, City Auditorium, Tri-Association Hall, and American Legion Hall. The early Sons of Hermann used the hall as well. Today, the most generally accepted name is Turner Hall.

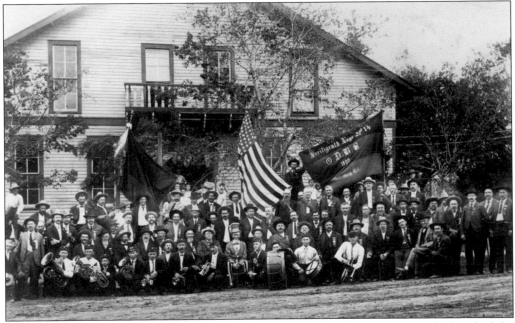

SONS OF HERMANN MEMBERS. In this c. 1906 photograph, local members and the band of the Sons of Hermann Lodge No. 14 pose in front of the Turner Hall. Note the man dressed as Uncle Sam at center. This photograph comes from the archives of Herzik Studios in Schulenburg.

TURNVEREIN MEMBERS. In 1886, the Schulenburg Turnverein, a German gymnastics club, erected Turner Hall (right) to promote gymnastics, calisthenics, and bowling, and to provide a community center for the largely German inhabitants of the town. Turner Hall became the common name for the building, which was constructed by Henry Bohlmann and was originally located on the corner of Summit Street (US Highway 90) and Upton Avenue.

SCHULENBURG WOW HALL. The WOW Hall is being moved through Schulenburg. The Woodmen of the World is a fraternal benefit society based in Omaha, Nebraska, that operates a privately held insurance company for its members. The society built numerous halls all over the country and many in Texas. Woodmen of the World chapters contributed more than $13,000 to hurricane and tidal wave victims after the historic 1900 storm in Galveston, Texas.

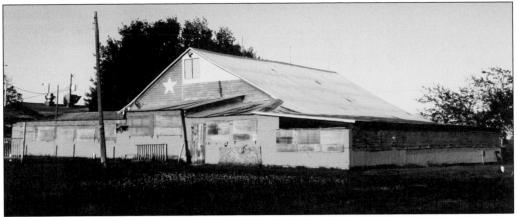

SWISS ALP HALL. Located on US Highway 77, the town of Swiss Alp is 11 miles south of La Grange in southern Fayette County. Swiss Alp Hall was built strictly as a dance hall around 1900 by one of the early settlers, Chas. Bruns. Having been a dance hall for all these years, it has seen the early days of polka and country music, then big band sounds, and, in the 1970s and 1980s, rock 'n' roll. Artists making regular stops here included John Baca, Bob Wills and His Texas Playboys, Adolf Hofner, and even Johnny Winter and B.J. Thomas. Unfortunately, the hall's use today is infrequent.

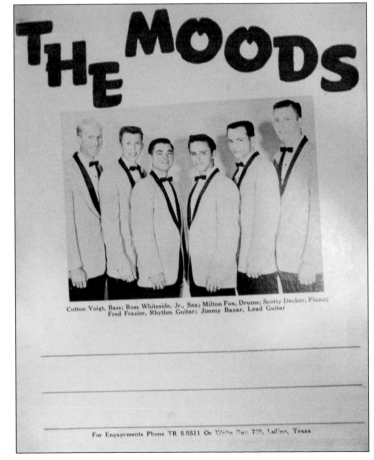

SWISS ALP POSTER. This vintage poster indicates the new type of bands that started frequenting Swiss Alp Hall in the 1960s. It was a departure from the typical music being played at the other halls. Swiss Alp was one of the few halls catering to the new sounds of rock 'n' roll, which carried it through the 1970s and 1980s before closing.

79

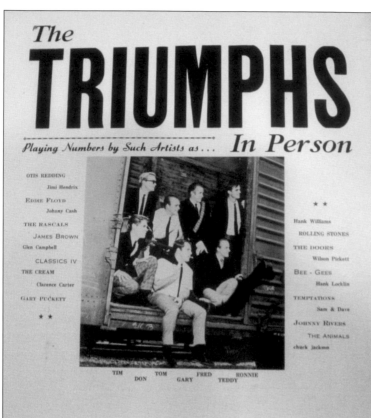

This is another vintage rock 'n' roll poster that hung in Swiss Alp Hall in the 1960s. Many area bands, such as The Moods and The Triumphs, had such a built-in audience in the local halls that they still play today, some 40 to 50 years later. Some of the artists have gone on to other careers in the music industry, and some of the bands continue, replacing older musicians who have retired or are deceased.

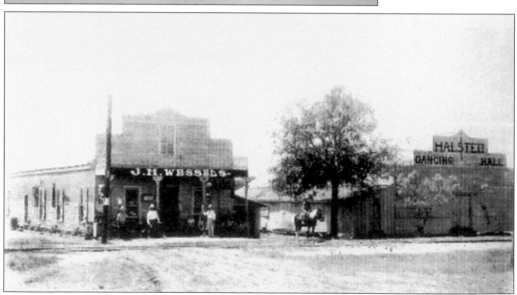

WESSELS HALL. Halsted is located at the crossing of Fayette County Road 124 and the Missouri, Kansas & Texas Railroad, five miles east of La Grange in eastern Fayette County. Land in the area was settled during the 1840s and 1850s and attracted Anglo and German immigrants. Seen here in 1915 is the John Wessels Store and dance hall. (Courtesy of Fayette County Historical Commission.)

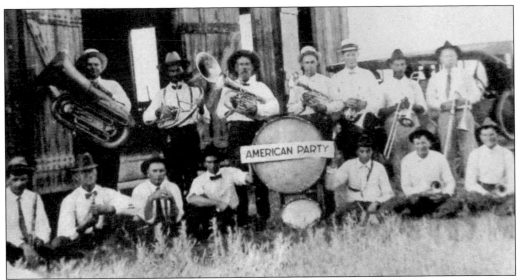

WALDECK HALL. The town of Waldeck, 13 miles north of La Grange in northern Fayette County, is at the junction of Farm Roads 1291 and 2145. Here, the American Party Band poses in front of the long-gone Waldek Hall. The predominantly German community is located on lands purchased in 1843 by Count Ludwig von Boos-Waldeck as an agent for the Adelsverein, an association of German noblemen who planned an emigration to the Republic of Texas. (Courtesy of Alfred and Nola Frenzel and Fayette County Texas Heritage.)

WALHALLA STORE AND HALL. Walhalla, at the intersection of Farm Road 1291 and County Road 209, is located 14 miles north of La Grange. Walhalla was originally a German settlement from the early 1830s, and it remained German until the 1900s. The Old Walhalla store, known as Frank's Ranch Store and the Old Saloon, which had a dance hall upstairs, was in business in the 1880s. The store was a gathering place for the community of about 50 residents. Some 200 yards from the store was Frank Zapp's cotton gin, which processed the main crop grown on the fertile black lands. The gin was torn down in 1955, and the store was demolished in 1970.

WARRENTON HARMONIE HALL. This is the Harmonie Hall and Legal Tender Saloon, still situated on County Road 237 in Warrenton. A vintage local newspaper advertisement states, "Remember that the Harmonie Hall has one of the best floors for dancing." It is still used at the antique fair as a bar and as a barn for antique sales.

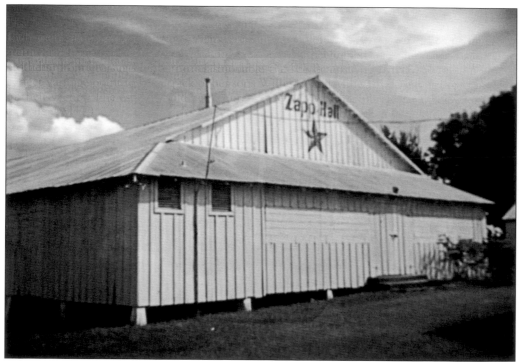

WARRENTON ZAPP HALL. This is the little-used Zapp Hall, located just off County Road 237 in Warrenton. Still in great shape, it is only used during the twice-annual antiques fair for the dispensing of food to the shoppers. The Round Top and Warrenton Antiques Fair, Texas's largest antiques show, is active in the spring and fall for roughly 10 days each. In this area, one can visit at least seven historic dance halls that were built here or have been relocated to the area for the showing of antiques.

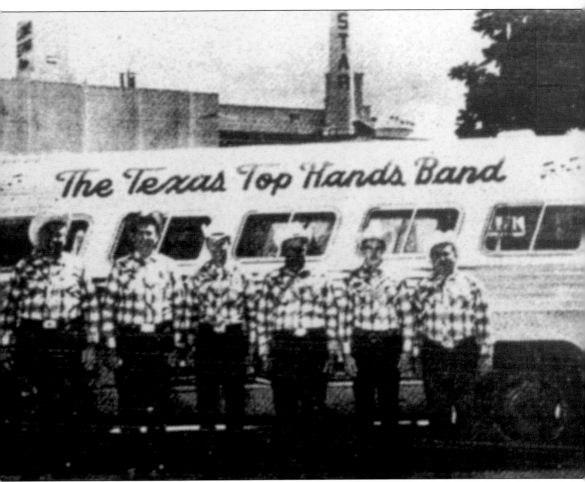

THE TEXAS TOP HANDS. As years passed, the music in the dance halls started changing, and many bands in the halls were playing more contemporary country-and-western or western swing sounds. The Texas Top Hands, based in San Antonio, was one of the busiest dance hall bands in Texas during its existence (1941–2011). In its heyday, the band performed 25 to 30 evenings a month. Besides touring relentlessly, it also recorded regularly and even made movie appearances. The Texas Top Hands is also renowned for having been the backup band on Hank Williams's last tour in Texas before his death.

LA GRANGE CASINO CLUB HALL. Pictured here is the Casino Gesellschaft (generally translated as "community" or "society"), which was located on North Main Street. It was a social hall and meeting place that hosted many fairs beginning in 1902. It also housed the American Legion post established in 1919. The building burned down in 1977. (Courtesy of Fayette Heritage Museum.)

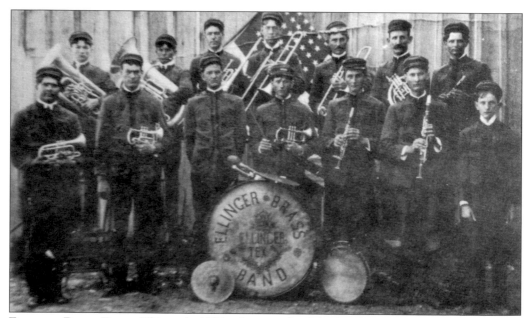

ELLINGER BRASS BAND. This early 1900s photograph of the band is an apparent advertisement for C.G. Conn Company brass instruments. The bandleader was Chas. Meyer Jr. (Courtesy of Fayette Public Library.)

Five

GOLIAD COUNTY

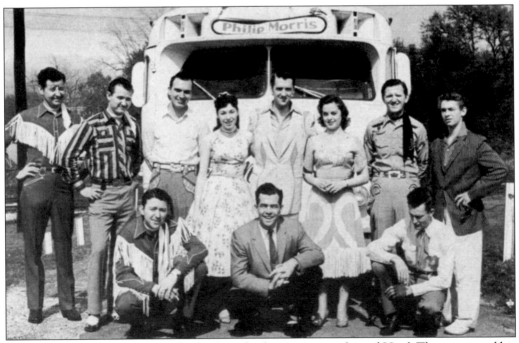

HANK THOMPSON. This is an early photograph of western swing legend Hank Thompson and his Brazos Valley Boys. Thompson toured the Texas dance halls for over 40 years and, as seen here, was sponsored by the cigarette company Philip Morris. Many of the early bands were even named after some sponsors, including the Light Crust Doughboys and the Pearl Wranglers.

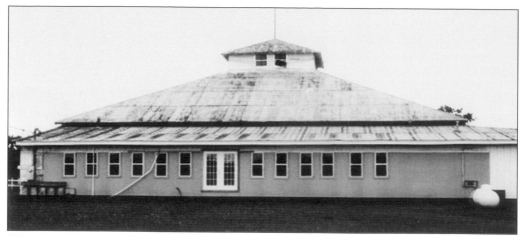

WEESATCHE. Located 13 miles north of Goliad in northern Goliad County on State Highway 119, Weesatche (also known as Wesatch and Wesatche) was established in the late 1840s or early 1850s. A dance hall was reported in 1900, and the hall shown here is purported to have been built in or around 1919. It is still used on occasion, and a popular café has been added to the side of the hall, serving locals most every day.

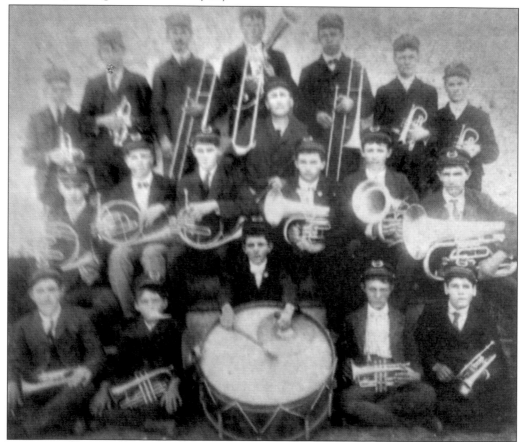

WEESATCHE BRASS BAND. All of these musicians were members of the local St. Andrews Lutheran Church in Weesatche. This photograph was taken in the early 1900s.

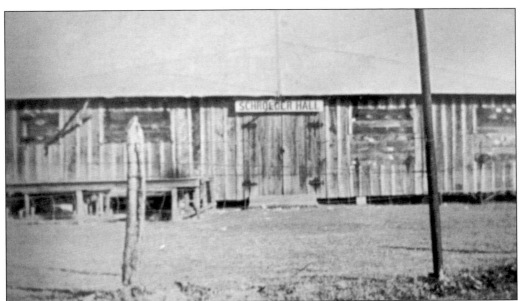

SCHROEDER HALL. Schroeder, originally named Germantown, is at the intersection of Farm Roads 622 and 2987, fifteen miles from Goliad in northeastern Goliad County. German immigrants began settling the area in the 1840s. The first dance hall was constructed and opened for business in 1890. In 1918, as a result of anti-German sentiments aroused by World War I, the town was renamed Schroeder. Built by E.P. Sherlen, Schroeder Hall remains one of the most popular dance halls in the state, with weekend dances featuring the top names in country music and other genres.

SCHROEDER HALL POSTER. This 1960s poster advertises an appearance by Ernest Tubb at Schroeder Hall. Tubb was one of the busiest and most frequent visitors to the Texas dance halls, having been born and raised in Texas. He continued to play the halls up until 1982, at which time illness forced him to quit.

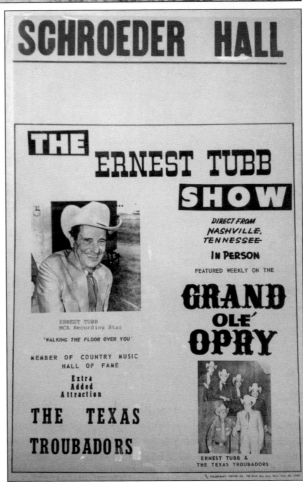

WESER HALL. Weser, on US Highway 183 in northern Goliad County, was settled in 1881 and named after the ship that brought the first Polish immigrants to Galveston in 1854. In 1900, Weser had a Sons of Hermann lodge, a brass band, and a dance hall, all typical of early German/Czech settlements. The unique round hall was used frequently until around 1955, at which time it was torn down. This photograph was taken in 1951. (Courtesy of Weesatche Hall.)

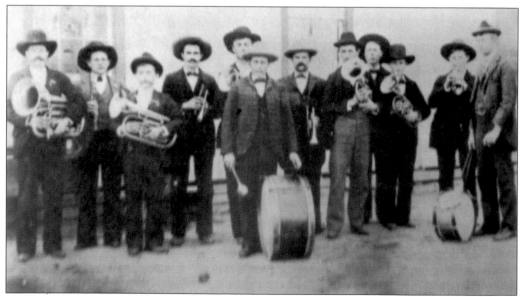

WESER BRASS BAND. Although the town of Weser never exceeded 150 people, there was a need in the community for the dance hall and a local brass band!

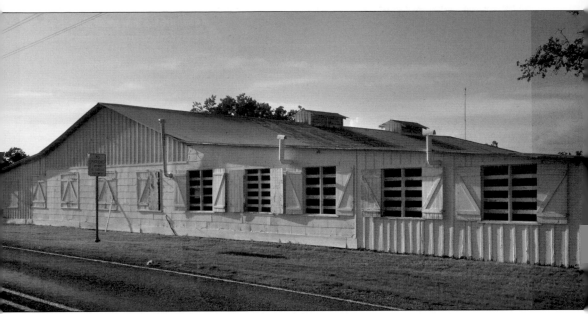

SCHROEDER HALL. This photograph shows the front of the large dance hall, facing the road. The hall, which can accommodate over 1,000 people, has hosted several music legends over the years. Willie Nelson, Merle Haggard, Ray Price, Loretta Lynn, Bob Wills, and many more have graced the stage.

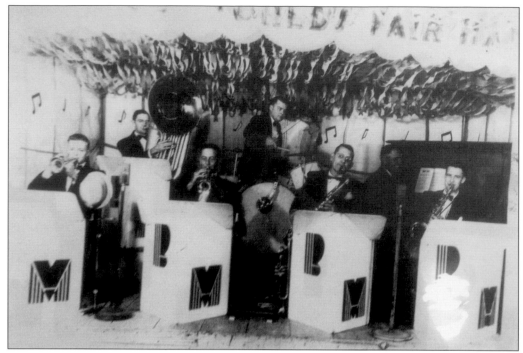

BURG MORISSE ORCHESTRA. Burg Morisse was born in 1911 and, by his late teens, had joined the Nordheim Brass Band. In 1935 he established his own group, playing the big band sounds of the day. The orchestra played all over Texas, including in Schroeder, Lindenau, Garfield, Tynan, Panna Maria, and in the dance halls of many other communities. The orchestra lasted well into the 1960s. (Courtesy of Yorktown Historical Museum.)

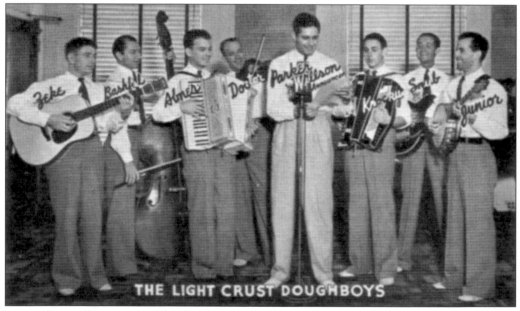

LIGHT CRUST DOUGHBOYS. This band was one of the earliest that played western dance music almost exclusively in dance halls all over the state. The band, sponsored by a flour company, is still together after 70 years.

Six

GONZALES COUNTY

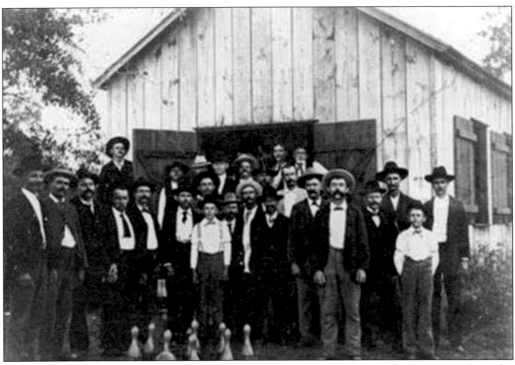

OTTINE BOWLING LEAGUE. Ottine is located nine miles northwest of Gonzales in western Gonzales County. Adolf Otto and his wife, Christine, built a gristmill that ran on water provided by the sulfur springs in the swamp next to the town. The state purchased 198 acres of the Ottine Swamp in 1933, and it was renamed Palmetto State Park. Here, the Ottine Bowling League poses in front of Scuetzen Verein Hall in the 1890s. The Germans and their Turnvereins brought nine-pin bowling to this country. Today, nine-pin bowling has disappeared from the United States except for Texas, where both nine- and ten-pin bowling have been known since the 1830s. Many of these bowling alleys were attached to the dance halls, and they can still be seen at those locations in many halls in Texas.

PILGRIM COMMUNITY CENTER. Pilgrim, on Farm Road 1116, is located 16 miles southwest of Gonzales in southern Gonzales County. The town's community center, shown here, was too small for many dances. However, it served the area, the population of which never reached more than 100 people, for many years. An earlier Odd Fellows group met on the top floor of a mercantile business. Pilgrim is also noted as the location of a hideout of notorious gunman John Wesley Hardin.

SMILEY IOOF HALL. Smiley was established in the early 1870s, when trader and sheepherder John Smiley settled by a long, narrow lake that became known as Smiley's Lake, or Smiley Lake. The lake became an important watering point for cattle herds on the way to market, and a community soon grew up around the area. Although not built as dance halls, IOOF halls, home to early benevolent organizations, would be used for other functions, including dances. Smiley, situated 21 miles south of Gonzales in southwestern Gonzales County, is at the intersection of US Highway 87 and Farm Roads 3234 and 108.

Seven

LAVACA COUNTY

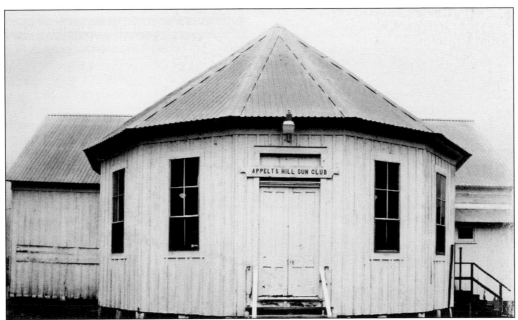

APPELT'S HILL SCHUETZEN VEREIN HALL. Organized in 1882, Appelt's Hill Schuetzen Verein (Gun Club) was organized in 1882, and built a dance platform shortly thereafter. In 1897, the club built its first hall just down the hill from the platform. It was destroyed by a storm in 1909 and rebuilt later that year, and this structure stands today. It is multi-sided and used for weddings, dances, and annual May and October King Fest celebrations. Appelt Hill is located on County Road 213/204, just east of Highway 77, north of Hallettsville.

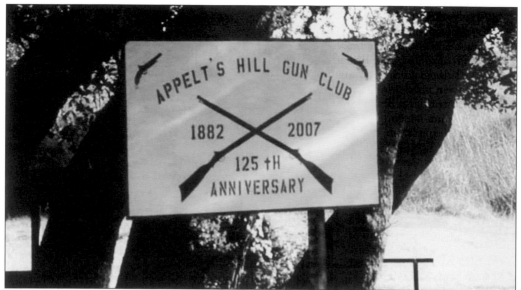

APPELT'S HILL GUN CLUB. This club, established in 1882, built a platform shortly thereafter. In 1897, it built its first hall just down the hill from the platform. The gun club still practices today and has an annual crowning of the Schuetzen Fest King (shooting champion).

BILA HORA. This is the SPJST Lodge No. 16. Bila Hora, Texas, located about 11 miles from Hallettsville in Lavaca County. It is the second-largest Moravian settlement in Lavaca County. The town name comes from the place in Bohemia where an infamous battle took place that led to the subjugation of the Czech nation by the Habsburgs for 300 years. The hall is still standing, but is in serious decay.

BLASE'S PLACE POSTER. This poster hung in Blase's store in Hallettsville for many years, as a reminder of the days when dances were held on most weekends. The band listed on the poster, the Worthing Brass Band, included Mr. Blase as a member. The hall still stands but is used less frequently today. It is located on Highway 90 just west of Hallettsville.

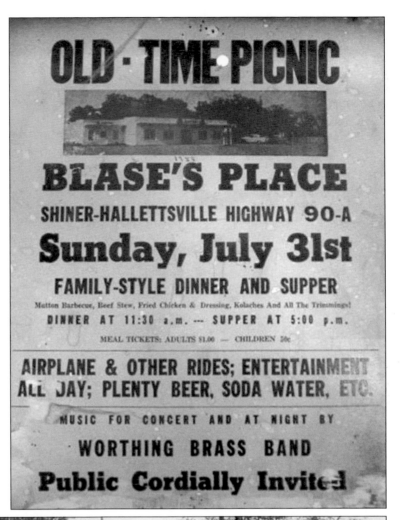

OLD · TIME PICNIC

BLASE'S PLACE

SHINER-HALLETTSVILLE HIGHWAY 90-A

Sunday, July 31st

FAMILY-STYLE DINNER AND SUPPER

Mutton Barbecue, Beef Stew, Fried Chicken & Dressing, Kolaches And All The Trimmings!

DINNER AT 11:30 a.m. --- SUPPER AT 5:00 p.m.

MEAL TICKETS: ADULTS $1.00 — CHILDREN 50c

AIRPLANE & OTHER RIDES; ENTERTAINMENT ALL DAY; PLENTY BEER, SODA WATER, ETC.

MUSIC FOR CONCERT AND AT NIGHT BY

WORTHING BRASS BAND

Public Cordially Invited

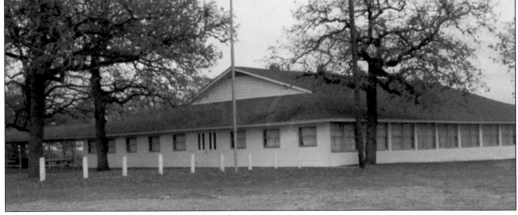

BLASE'S PLACE. This dance hall served the German/Czech community for many years. The property, owned by Mr. Blase, initially held a small store, and then, in 1948, a dance platform was added under the trees. In 1960, the hall was built. Blase was a musician, and his band was a featured performer here.

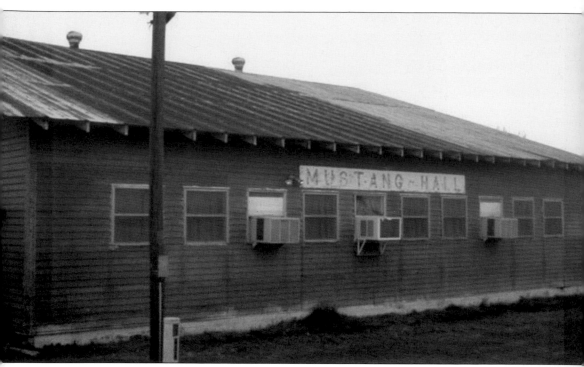

MUSTANG HALL. Hallettsville, the county seat of Lavaca County, is on the Lavaca River at the intersection of US Highway 77 and US Highway 90A, 80 miles southeast of Austin. Many who settled in Hallettsville in the late 19th century emigrated from Czechoslovakia and Germany. This is Mustang Hall, just outside of town to the west. A popular dance hall for many years, it is now closed and listed for sale.

KINKLER HALL. During and after the Civil War, the original Anglo American settlers of Kinkler were gradually replaced by German and Czech immigrants, who divided the large ranches into farms. Although the community never exceeded 70 people, the small hall served many functions for local farmers, including as a dance hall. Kinkler and nearby New Kinkler are on US Highway 77 and Lavaca County Road 214, seven miles north of Hallettsville in northern Lavaca County.

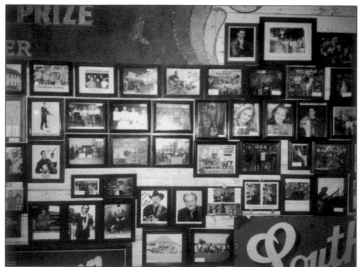

MORAVIA STORE. Shown here are the many autographed photographs on the wall at the Moravia Store. Many performers play here, especially Czech-style polka bands. The predominantly Czech town of Moravia is a classic example of a small community still retaining its ethnic heritage. This store was built as a two-story saloon in 1889.

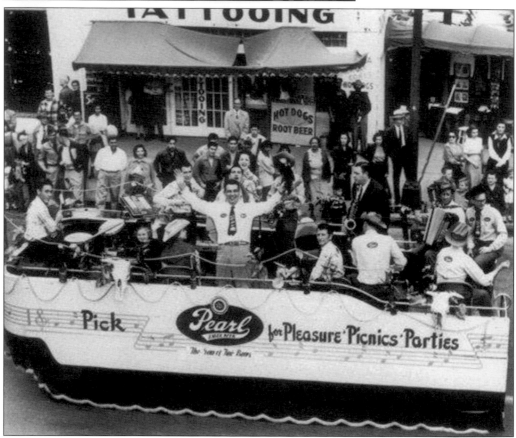

ADOLF HOFNER BAND. Adolph Hofner (standing front row center) was born in Moulton, Texas, in 1916. His father was part German, and his mother was of Czech extraction. Adolph and his younger brother, Emil, grew up speaking Czech. Adolf, recognized as a western swing pioneer, played in polka bands as a teenager and often mixed the two genres, depending on the dance hall where he was playing. The regional dance halls provided venues for him for well over 60 years.

MOULTON SPJST HALL. Moulton SPJST was organized in October 1897, and this photograph of the hall was taken around the turn of the century. An Odd Fellows Hall had preceded it in 1875. By 1914, the town of Moulton had its own opera house as well, and close to 800 people. Moulton is at the intersection of State Highway 95 and Farm Roads 532 and 1680, on the Southern Pacific Railroad, 16 miles northwest of Halletsville in northwestern Lavaca County.

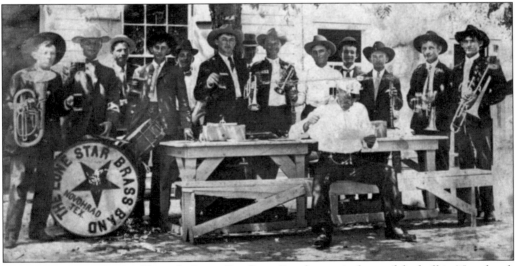

LONE STAR BRASS BAND. Here, the Lone Star Brass Band poses in front of the hall in Novohrad. The farming community is 10 miles northeast of Moulton on Farm Road 1295 in northern Lavaca County. There in 1880, Frank Migl built a store and cotton gin, and J.R. Jasek, formerly a botanist for the government of Bohemia, operated a nursery. The community that grew around these businesses took its name from a town in Bohemia. The first hall was built in 1883 and demolished in 1931, to be replaced by a new hall, which was then demolished in 1956.

SHINER AMERICAN LEGION HALL. Shiner is at the intersection of US Highway 90A and State Highway 95, west of Hallettsville in western Lavaca County. Czech and German immigrants soon became the dominant ethnic groups, and Shiner developed a cohesive Czech community through social organizations such as the National Sokol Society and the Slavonic Benevolent Order of the State of Texas. The town is widely known for its Shiner, a German-style beer founded in 1909. The company's brewery is the oldest independent brewery in Texas. The American Legion (Round) Hall is the center of Shiner's activities, including many ethnic festivities.

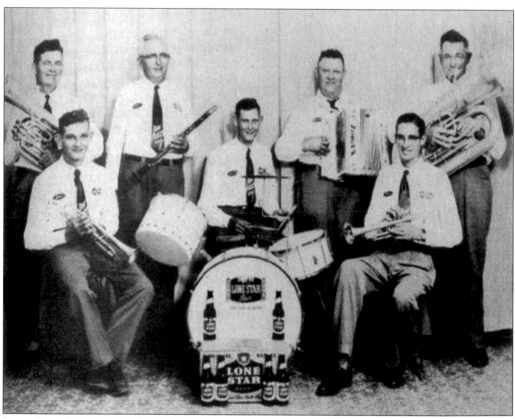

LONE STAR BAND. Many bands called themselves the Lone Star Band, and this one hailed from Shiner. Joseph Panus immigrated to Galveston as a nine-year-old boy with his family in 1906. He played accordion for over 50 years and performed at the platforms and halls of Sunken Gardens, Swiss Alp, Kokernut Grove, Boedekers, Cotton Grove, and Bluecher Park. He also played most of the church picnics in Moravia, Witting, Sweet Home, St. Mary's, St. John, and Koerth. The band played until 1960, when Panus suffered a heart attack and retired from music.

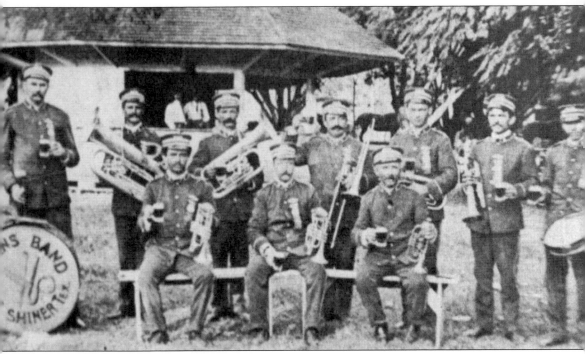

SHINER FIREMANS BAND. Members of the Shiner Firemans Band stand in front of the lemonade stand near the gazebo, where many of the bands played in the afternoon. This site was located just outside of Bluecher Park Hall, built by Edward E. Hildebrandt. This hall was later remodeled, with much of the old hall lumber kept intact and the building retaining its circular design. It is now called K.C. Hall and is located at the park in Shiner at 3081 US 90 alternative.

SPEAKS HALL. The town of Speaks is located 20 miles southeast of Hallettsville in Lavaca County, on Farm Road 530. In 1828, Jesse H. Cartwright received from the Mexican government a small grant of land on the east side of the Navidad River near the crossing of the Atascosito Road. Very little is known about this hall, but its classic rectangle style is typical of early economical halls, along with pier beam suspension, continuous windows that are rope raised, board and batten outside walls, and simple pitched tin roof. These features distinguish it from simple barns that dot the landscape.

SWEET HOME HALL. In 1949, the Kutac family donated two acres of land to the SPJST Lodge No. 63. A new hall was built using lumber from an old dance hall in town, The Wagon Wheel. Around 1958, it was purchased by the fire department, then, sadly, in 1965, the hall was demolished by Hurricane Beula. It was rebuilt following the storm. In 1990, the hall was purchased by the Yoakum Community Bingo Club for use as a community center, officially named Sweet Home Hall.

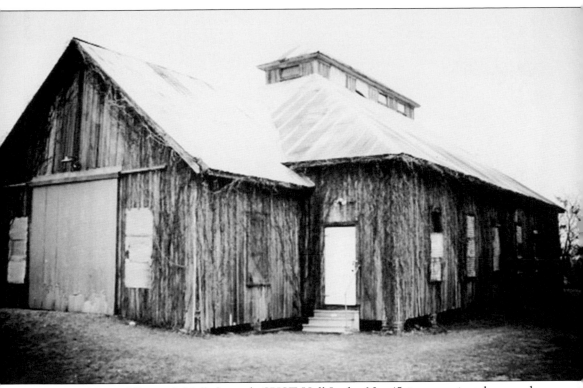

VLASTINEK HALL. Vlastinek Hall, formerly SPJST Hall Lodge No. 45, is now privately owned. It is located at the intersection of County Roads 966 and 336, just southwest of Shiner, Texas. It was built around 1913.

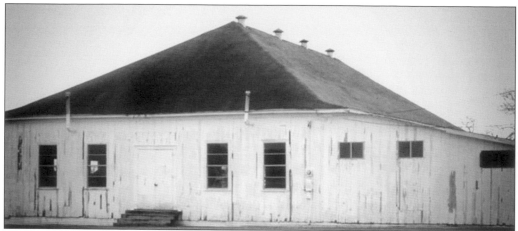

WIED. First settled by Germans in the 1830s, the town of Wied saw Czechs move into the area in the late 1800s. Wied's population never exceeded 100, but it constructed a church and a community hall, once again showing the importance placed on a hall for cultural activities. This hall was built around 1896 for A.J. Kallus, who later sold it to shareholders for the community. It still stands today but is used infrequently. Wied is on Farm Road 1891, just north of US Highway 90A, midway between Hallettsville and Shiner in west central Lavaca County.

MORAVIA PARISH HALL. This is the parish hall belonging to the historic Moravia Catholic Church. It is used infrequently, but is always open during the annual church picnic, where many polka bands play throughout the day. The hall was built in 1940 and sits across from the church on FM 957.

Eight

VICTORIA COUNTY

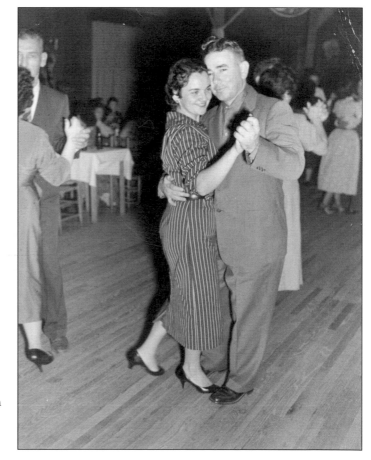

CLUB WESTERNER. For the past 53-plus years, the Club Westerner has been owned and operated by the John M. Villafranca family and its heirs. The club has been notable in bringing many Tejano stars to the hall. After World War II, many of the halls started to reflect emerging ethnic demographics, as returning servicemen had more expendable income. Shown here are Mr. and Mrs. Villafranca. (Courtesy of James Phillip Villafranca.)

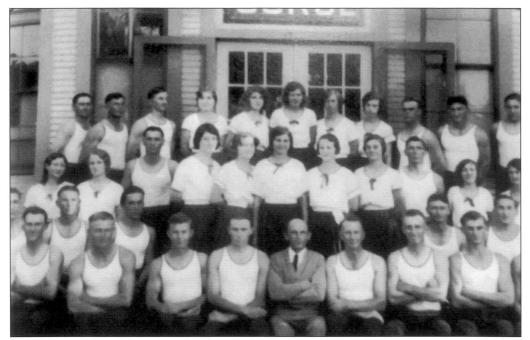

PLACEDO HALL. The town of Placedo is on US Highway 87, southeast of Victoria in Victoria County. A settlement has existed at the site since the Republic of Texas era. Here, young Czechs, members of the Sokol gymnastic team, pose in front of the Sokol Hall in 1930. The Sokol movement (from the Slavic word for falcon) is a youth sport movement and gymnastics organization first founded in Prague in the Czech region of Austria-Hungary in 1862.

RAISIN. The town of Raisin is on US Highway 59, southwest of Victoria in Victoria County. It was established in 1889 as a stop on the Gulf, Western Texas & Pacific Railway line from Victoria to Goliad and Beeville. The first business purportedly was a small brewery, and the new town quickly became the focus of the nearby German settlement of Coletoville. C.G.T. Friedrichs, the first postmaster, built a gin and saloon. Later, the nearby Coletoville Schuetzen Verein built the hall shown here around 1891. It was used by the Farmers Alliance and the local Sons of Hermann.

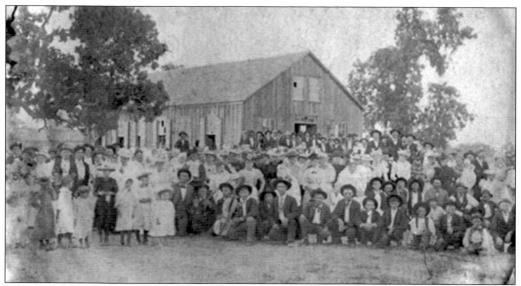

FREDERICH'S HALL. The town of Raisin got the railroad when the Gulf, Western Texas & Pacific Railway came through in 1889. This contributed to the growth of the town. Shown here is a gathering of people from Raisin, Texas, at the original Schuetzen Verein, later known as Frederich's Hall, around 1890. (Courtesy of Frank Richard Brown and Preston Carl Kobitz.)

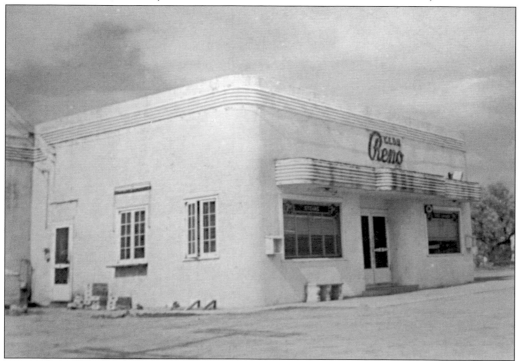

CLUB RENO. This dance hall, located on Goldman Hill west of Victoria, is seen around 1941. It was owned by William "Bill" Lindsey. This hall, in the Art Deco style, shows how the architecture was rapidly changing with the times. But dancing was still the central entertainment after World War II. Along with the changes in design, the music also was changing, to the big band sounds of the day.

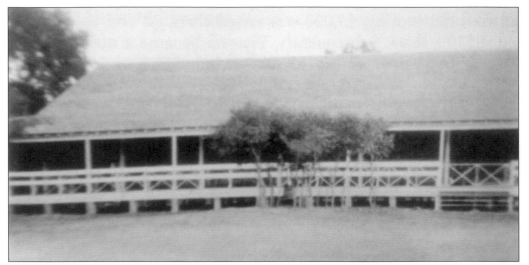

DaCosta. The community of DaCosta, on US Highway 87, is 10 miles from Victoria in southeastern Victoria County. The town was established in 1860 when the San Antonio & Mexican Gulf Railway completed its route from Victoria to Port Lavaca. A post office was established there in 1903, and a local social center and dance hall, which also housed the Guadalupe Sons of Hermann Lodge, was built. Shown here is the DaCosta Sons of Hermann Lodge No. 265 Hall, which no longer stands.

Victoria Opera House. Victoria is also one of the state's old, historic cities, having been established in 1824. This is Victoria's first opera house, built in 1839. It was located on William and South Streets. Towns often constructed opera houses for the community's cultural needs, and many times, these places hosted dances when the occasion presented itself. These structures were more ornate and always located in the more established and larger towns.

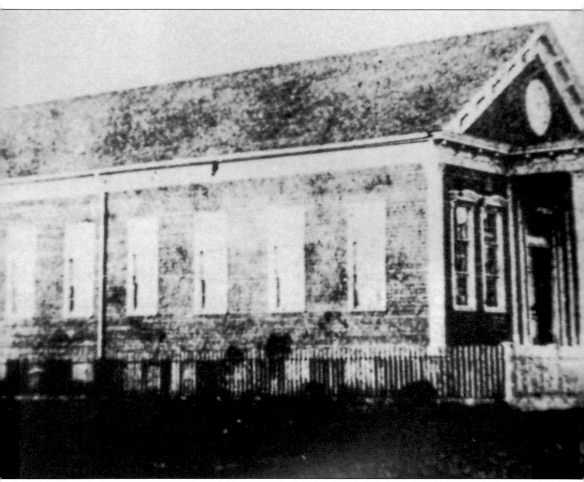

Victoria Casino Hall. The Casino Hall was built in 1854 at the corner of Liberty and River Streets. In 1875, it was moved to Bridge Street. It served the community for many years before being torn down and replaced by the new opera house. Casino halls were social clubs for benevolent activities, dancing, socializing, and maintaining German culture. They were not used for gambling.

URESTI HALL. The town of Nursery, on US Highway 87, is located northwest of Victoria in Victoria County. It is named for the fact that horticulturist Gilbert Onderdonk established a branch of his nursery on the San Antonio & Mexican Gulf Railway in 1883.

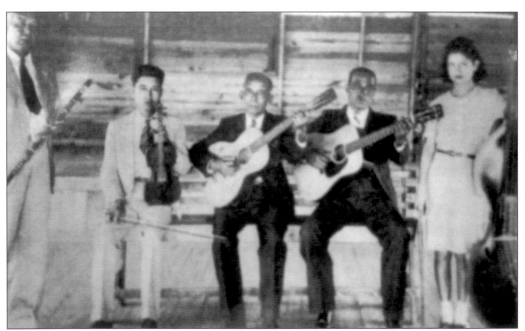

PEREZ FAMILY BAND. The Perez family started performing in the late 1890s around the Victoria and Goliad area, including at Hauschild's Opera House. This photograph, showing the family band around 1930, was probably taken inside the Uresti Hall in Nursery.

Nine

WASHINGTON COUNTY

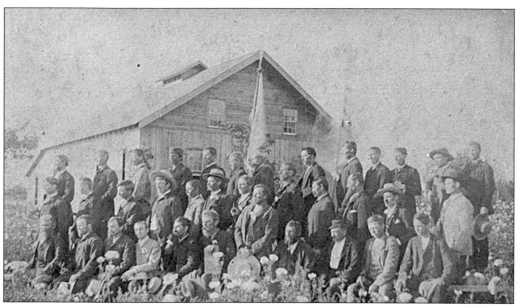

LA BAHIA TURNVEREIN HALL. On July 5, 1879, in the vicinity of Burton, Washington County, Texas, 48 German settlers organized the La Bahia Turnverein. In the club's statutes, the declared purpose was to further physical and spiritual development of its members and to promote social life. On June 24, 1884, the Verein purchased three acres of land from August and Amoelia Seibel for $90. This land fronts present-day Texas Highway 237. G.F. Christek constructed the first hall (shown here) on that land. This building was destroyed by fire on November 3, 1887. A second hall was built that same year. It burned down on October 12, 1901.

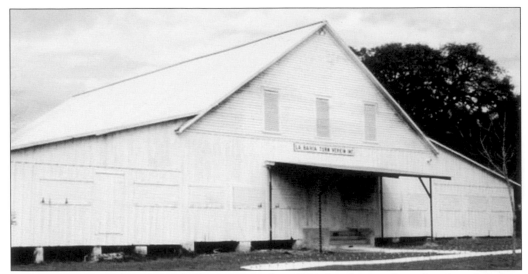

LA BAHIA HALL. The present hall, constructed in 1902, has been enlarged and modified on several occasions as the number of members and people attending functions increased. In 1929, the La Bahia Turnverein purchased an additional three acres. A portion of this land was used as a baseball field for many years, where members of the La Bahia Turnverein played games against teams from nearby communities.

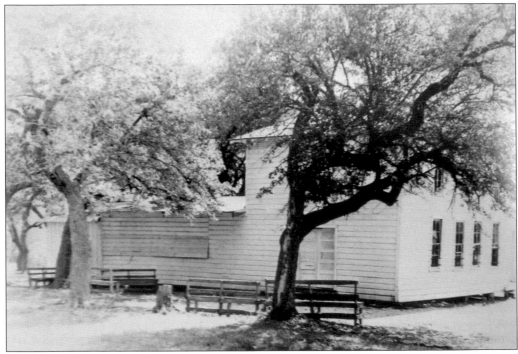

BURTON UBF HALL. This is the United Brothers of Freedom Hall in Burton. It was built in 1919 as a German Harmonie Verein. A dance platform occupied the site prior to the construction of the hall. It was bought by the UBF Lodge in 1934.

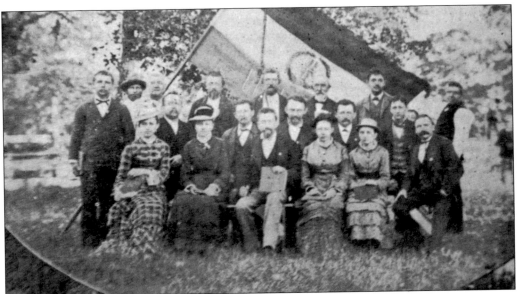

DER GESANGVEREIN MOZART. Some of the earliest music brought over by the early European settlers was the cultural songs of their homeland. Shown here is a very early German Gesangverein (choral or song club) in High Hill, Texas, in 1868. In the many German settlements, music was a very important part of the culture. The halls were the venues for that activity.

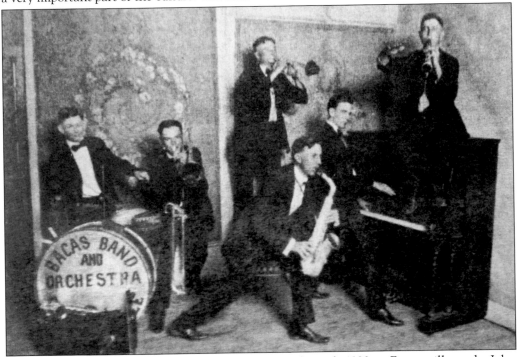

BACA ORCHESTRA. The Baca Orchestra is seen here in the early 1920s in Fayetteville, under John Baca's direction. This photograph demonstrates how the band was assimilating to the current sounds of big band Jazz and Dixieland, but keeping the Baca beat. The music book they were playing from probably still had many traditional songs from the earlier days. The hall or area where the band was playing determined the direction the music went.

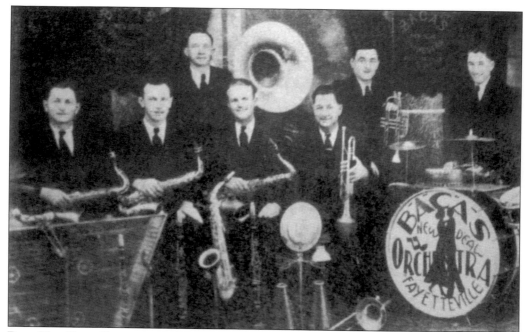

BACA NEW DEAL ORCHESTRA. The Baca Band is seen here in 1933 in Fayetteville, Texas. The group was now under the direction of Ray Baca. As shown by the dancing couple motif on the drumhead, the band had taken on a definite big-band style.

BACA BAND. This is how the Baca Band looked in 1966, still under the direction of Ray Baca. Note the electric instruments and, in particular, the accordion. The accordion-driven polkas were and still are a huge part of the dance bands that make up many of the East Central Texas dance halls. As the population ages, the dance halls are moving to earlier times; sometimes, Sunday afternoons are the preferred time for the people who still dance the schottische and polkas.

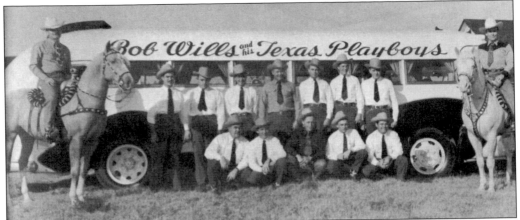

BOB WILLS AND HIS TEXAS PLAYBOYS. This is a 1946 photograph of the King of Western Swing and his band. This form of music was born and bred in the hallowed halls of Texas and is today still carried on by many new bands, in particular the Grammy Award–winning Asleep at the Wheel. Western swing is perhaps the perfect example of a music that reflects the many cultures of Texas, bringing together jazz, country and western, cowboy, Appalachian, Mexican, the blues, pop, and Tin Pan Alley sounds. It is now the Official Texas State Music, as designated by the state legislature.

BOB WILLS. This c. 1965 photograph is from Wills's later years. He is shown performing in one of the Texas dance halls. Bob Wills built his reputation and popularity in the many dance halls, and would continue to return to the Texas halls even after a long and illustrious career that included motion pictures and hundreds of recordings.

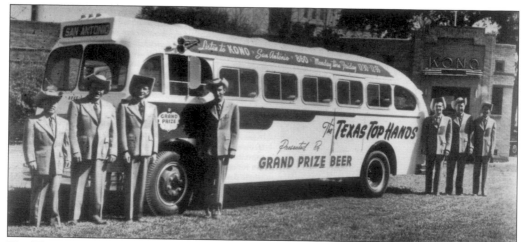

The Texas Top Hands. Western swing is one of the music styles born in the Texas dance halls. This 1950 photograph of the Texas Top Hands shows two reasons why Texas and western swing music was so popular: the tour bus, and the radio stations that played the local and regional music. Another contributing factor was the numerous dance halls located so close to one another all over the state. The Top Hands played as many as six or seven nights a week in Texas and was one of the state's oldest continuously performing western swing bands, having formed around 1945.

Hank Williams. This is a photograph of the legendary Hank Williams (standing, far right) at one of the historic Texas dance halls in the early 1950s. Williams's last tour was in Texas, before his untimely death on New Years' Day 1953. The dance halls were crucial to the country-and-western stars of the era. The halls still feature many of today's musical acts, but mass media, urban development and migration, and natural disasters have taken their toll on their popularity.

ELVIS PRESLEY. Here, a young Elvis Presley performs on a crowded stage at a small central Texas dance hall in 1955. Texas was a fertile ground for emerging performers, who would often tour the state after playing the wildly popular Louisiana Hayride, on the Texas-Louisiana border in Shreveport. Presley was an early Hayride performer after being shunned at the Grand Ole Opry in Nashville. The dance halls of Texas have routinely supported the vast Texas music milieu and helped to create and nurture several iconic Texas music styles over the years. (Courtesy of Stanley Oberst.)

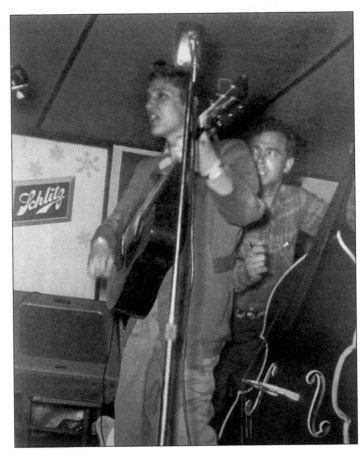

BIG SHOW AND

DANCE

K. W. K. H's.
LOUISIANA HAYRIDE
Entire Cast in Person
Clovis Presley
With Scotty and Bill, Jimmy
and Johnny, Johnny Horton,
Betty Amos, Dalton and Lula
Jo, Billy Birdbrain (comedian)
Horace Logan, M. C.
Producer of
LOUISIANA HAYRIDE
Eleven Great Artists, along
with ELVIS PRESLEY'S BAND

Cherry Springs
Tavern

SUNDAY NIGHT, OCT. 9th
Starting 8:00 P. M.

Admission: $1.50.

ELVIS PRESLEY ADVERTISEMENT. The Texas dance halls were so numerous and profitable for so many years that many of the nation's biggest stars would perform in them while touring the state. This was the case with Elvis Presley, who spent a considerable amount of time in his early days in the Texas dance halls. Between 1954 and 1958, he toured Texas more than anywhere else in the United States.

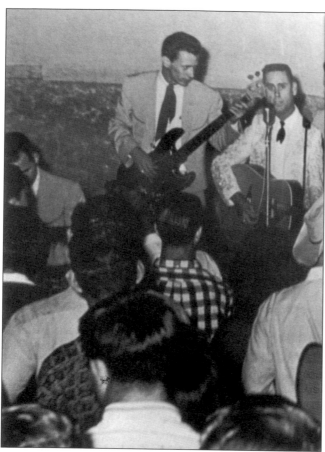

GEORGE JONES. This is a photograph of George Jones playing in one of the small Texas dance halls early in his career. Jones, born and raised in East Texas, absorbed the honky-tonk sounds emanating from the various dance halls and juke joints in that area. (Courtesy of Bob Allen.)

YVONNE'S CLUB AND DANCE HALL. During the second half of the 20th century, returning servicemen brought about a need for more social centers or dance halls. Many of these halls would become more honky-tonks than traditional dance halls, and the family element was minimized. This is the site of several Hank Williams and Ernest Tubb shows. This place is also where George Jones often performed. Although not in East Central Texas, it still shows the influence of the early dance halls on the careers of the major developing country stars. (Courtesy of Bob Allen.)

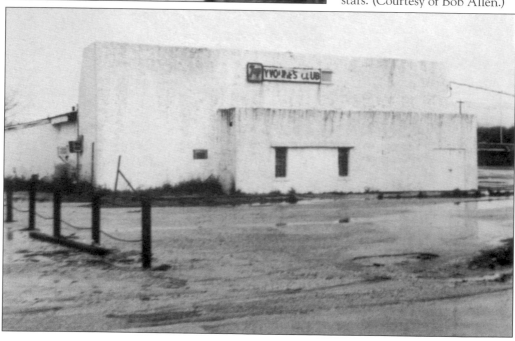

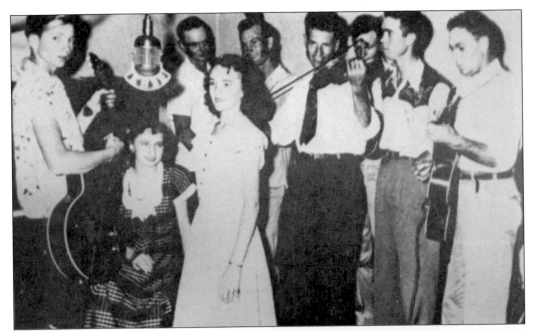

WILLIE NELSON, C. 1948. This is a very early photograph of Willie Nelson as he was performing in the numerous dance halls around his Central Texas home. He is seen here at the far left. Also shown here are his sister Bobbie and her husband, Bud Fletcher (on fiddle) and his band. Willie's father, Ira "Pop" Nelson, is on guitar at far right.

WILLIE NELSON, C. 1970. Here, Willie Nelson is seen as he was making his way through the Texas dance halls and just beginning to build an audience there. This photograph is from 1970, when he was beginning his new look and returning to Texas after his Nashville phase.

GEORGE STRAIT. This is a photograph taken early in the career of George Strait. He is performing in one of the many small dance halls that were a weekly occurrence for most of the Texas country bands at the time. Strait is the biggest-selling performer in the history of country music, and it all started in the Texas dance halls, a continuation of the halls that nurtured the music since their first appearance in the mid-1800s.

NARCISO MARTINEZ. Conjunto is one of the indigenous music styles born in the Texas dance halls and cantinas. The music is a melding of traditional Mexican music of south Texas and the German button accordion polka style introduced at the end of the 19th century. This is one of the fathers of Conjunto music, Narciso Martinez, who began performing in the 1930s after absorbing Czech and German polka music at dances in the late 1920s.

120

LITTLE JOE HERNANDEZ. One of the legends of the musical style known as Tejano (indicating a Texan of Spanish or Mexican heritage), Hernandez spent a good bit of his life in the historic Texas dance halls. As the racial tensions eased, particularly after World War II, Hernandez was influenced greatly by the polka beat of Conjunto music, which had borrowed from the earlier German and Czech accordion styles. In providing a venue for bands, the dance halls were heavily responsible for the indigenous Conjunto and, later, Tejano styles of music.

HARRY CZARNEK AND THE TEXAS DUTCHMEN. This image is taken from a 1970s LP record of a popular band that was carrying on the Czech tradition of polka music. The old-style brass-band tradition of Texas-Czech polka music is mixed with a diverse range of influences, including western swing, jazz, and country-and-western music. Harry Czarnek and the Texas Dutchmen are pictured near the townsite of Praha, Texas, and its famous "painted church" and large meeting/dance hall.

CZECH FESTIVAL AT ENNIS. Popular events in Texas, especially in Central Texas, are the ethnic German and Czech festivals. Seen here is the National Polka Festival, celebrated in Ennis every year. In Central Texas, celebrations are held frequently throughout the year. There are the German Oktoberfests and the numerous church picnics that feature ethnic food (especially sausages), beer, and dancing. Many of these celebrations are held in the local dance halls.

BARBECUE PITS. The dance halls almost always had attached barbecue pits, to feed the people who attended the many functions. The Germans, Czechs, and Poles brought with them culinary traditions from centuries past, and these heavily influenced the Texas barbecue culture. There is a reason why Central Texas has the best barbecue in the nation.

GERMAN-STYLE SAUSAGES. Homemade sausages have become a staple in much of the Central Texas area. These popular German-style meats were first sold at the old ethnic butcher shops to the many rural farm workers and townsfolk in early Texas history.

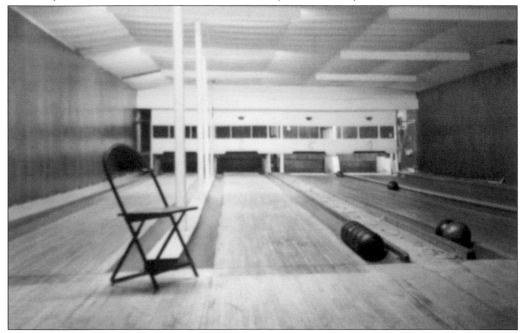

BOWLING LANES. The early Texas dance halls that featured attached nine-pin bowling lanes had a big impact on the small towns, whose main social outlets for many years were bowling and dancing. The German Turnverein movement was most responsible for this activity in Central Texas. Turnvereins contributed to the standardization and popularization of bowling nationwide. There is still a nine-pin bowling league in Central Texas.

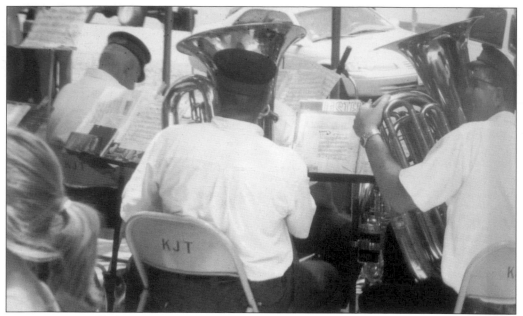

ROUND TOP BRASS BAND. The brass-band tradition still holds forth today in many of the dance halls in East Central Texas, as shown here with the Round Top Brass Band at Ammansville Hall. This area, known to some as the polka belt, is host to a large German and Czech culture. Polka bands perform regularly at these iconic dance halls, which also feature many other styles of music and continue to nourish the Texas music community.

GENERATIONAL DANCING. Here, a grandmother teaches her grandson how to dance in a traditional Texas dance hall. A main feature of traditional dance halls is the family atmosphere predominant at the functions. Another effect that the halls have had is the prominence of the dance culture, still rich in Texas. In particular, the older styles, such as the two-step and polka, continue to thrive.

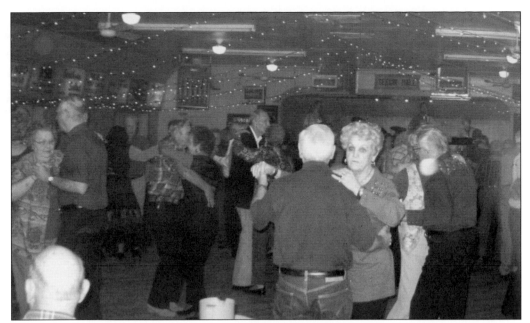

DANCING. One of the most important cultural aspects of the Texas dance halls is, simply, the dancing. This activity brought together the sexes and was the one place where the isolated communities could go for fellowship, visiting, and meeting potential mates. Dancing in Texas is still an integral part of everyday life, especially in the Central Texas dance halls, where the age-old customs still resonate.

TWO-STEP DANCING AND BEER. The Texas dance halls have contributed heavily to several cultural mainstays, among them dancing and beer. The bright neon signs have been sung about in hundreds of songs, and the German and Czech beers have had an immense influence on the American beer industry. The dance halls have also contributed to keeping dancing alive in the culture, so much so that Texas is perhaps the biggest dancing state in the country.

WBAP Radio Studio. At one time, the radio was the media focus for the populace, including in Texas. This is the means by which one heard the latest news and the newest music from all of the popular entertainers. It was also the utility that disseminated crucial information for the local and regional dances in the Texas dance halls. Many entertainers had their own radio shows broadcast from similar studios to promote themselves and their appearances.

Texas's First Television Program. This is the television remote of Harry Truman's speech in Fort Worth in 1948. Television has been cited as one of the contributing factors for the slow decline of dance halls' popularity. Along with other amusements in the larger urban center, television has been eroding enthusiasm for what was once the premier social activity of the Texas audience.

DANCE HALL WARNING. Shown here are signs at the entrance of one of the older Texas dance halls. The rules have softened, but these notices reflect a time when family values and discipline were important to the social mores of the community.